BOSTON'S ROYAL ROOTERS

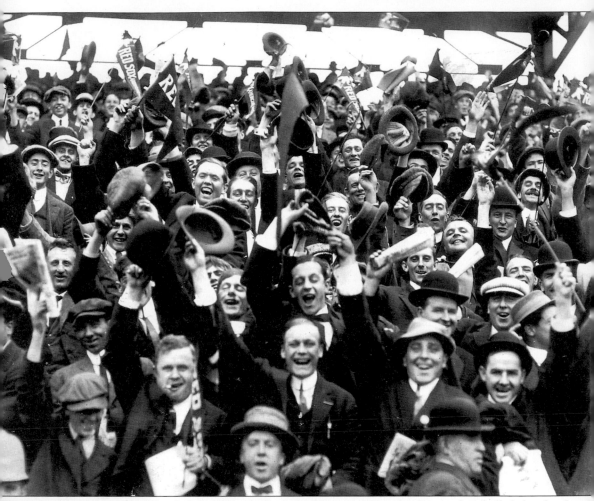

First known as "Kranks" (or "Cranks") in the Victorian age, the Boston baseball diehards of the 20th century set the standard for fan participation in organized baseball and other team sports that came later, like football and basketball. With their badges, buttons, pennants, signs, and megaphones, Boston's Royal Rooters established a tradition of intensifying the home-field advantage as well as revolutionizing the idea of fan road trips. Their exploits established Boston as the birthplace of baseball's 10th man. This image captures the traveling rooters cheering on the Sox to victory during the 1912 World Series. (Courtesy of the Garland Collection.)

BOSTON'S
ROYAL ROOTERS

Peter J. Nash

Published by Arcadia Publishing
Charleston SC, Chicago IL, Portsmouth NH, San Francisco CA

Printed in Great Britain

Library of Congress Catalog Card Number: 2005923150

For all general information contact Arcadia Publishing at:
Telephone 843-853-2070
Fax 843-853-0044
E-mail sales@arcadiapublishing.com
For customer service and orders:
Toll-Free 1-888-313-2665

Visit us on the internet at http://www.arcadiapublishing.com

To the memory of Nuf-Ced McGreevy, T. H. Murnane, and Lib Dooley.

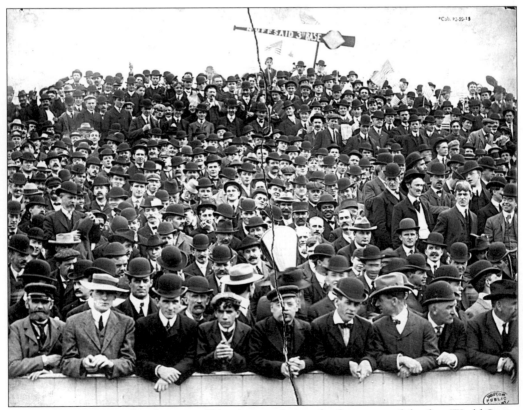

The Roxbury Rooters play the part of bleacherites during the first game of the first World Series in 1903. (Courtesy of the BPL Print Department.)

CONTENTS

ACKNOWLEDGMENTS

This work is published in conjunction with the establishment of the Baseball Fan Hall of Fame in Cooperstown, New York. Here, the story of the American fan is told within the confines of a gallery built to replicate the interior of Nuf-Ced McGreevy's baseball shrine, the 3rd Base saloon. Exhibitions include artifacts from the early Boston baseball scene, as well as fan-related items from the past 150 years. The most prominent fans in baseball history are honored annually.

I thank the descendents of the original rooters who provided their stories and images to help tell the story of the Royal Rooters. I thank Bruce Garland for access to his images from the 1912 World Series. Special thanks are also extended to Tiffany Howe of Arcadia Publishing, Aaron Schmidt and Jennifer Latchford of the Boston Public Library (BPL), Glenn Stout (for his work with the McGreevy Collection), Ian McFarland and Anthony Moreschi, Ken Casey, the Dropkick Murphys, Marianne Burke, Dianne Meyer, the Boston Red Sox and vice president Dr. Charles Steinberg, Colleen Reilly, Brita Meng Outzen, Arthur Pollock and Faith Ninivaggi of the *Boston Herald*, Bill Burdick, Claudette Burke, Tim Wiles, Bill Francis and Tom Sheiber of the National Baseball Library, Carol Smith of Boston Photo Imaging, Joanne Hulbert, the Holliston Historical Society, Penny Kleinpeter, the Plymouth Historical Society, Alice Thompson, Katherine Dooley, Thomas Jalkut, John Dooley, Linda Ruth Tosetti, Ken Felden, Sen. Edward Kennedy, Melissa Wagoner, Tom Fitzgerald, Michael Allen, Sandy McCall, James Walsh, Scott Van Pelt, Tom Heitz, Rick Tenney, Vin Russo, the Quinn family, the Leary family, the Criger family, the Dudley brothers, Johnny Coppolla, the Boyd family, Maryrose Grossman, the JFK Library, Charles Donovan, Jerry Casway, John Fitzgerald, Bob Wood, Al Caprera, Lenny Manzo, Twins Enterprises, John Kashmanian, the Erskine family, Jason Grey, Angela and Beverly Thomas, Jim Merlis, Barry Feldman, David Block, 3rd Baseman Michael Berrin, Paul Reiferson, Barry Goldenberg, Grant and Deb Thayer, John Stote, Anaconda Sports, Al Angelo, Ted Spencer, Jeff Idelson, Jeff Horrigan, Mark Cates, Terrie Bloom, Mariellen Norris, Rosemarie Sansone, Robert Lifson, David Hunt, and Suffolk University.

Sources utilized include the McGreevy Collection and Red Sox–related works by authors Dan Shaughnessy, Bob Ryan, Glenn Stout and Richard Johnson, Leigh Montville, Louis Masur, Roger Abrams, Ed Linn, David Halberstam, Ellery Clarke, John Holway, Richard Tourangeau, Troy Soos, Kerry Keene, Ray Sinibaldi, David Hickey, Allen Wood, Mike Vaccaro, Jim Prime, and Bill Nowlin.

INTRODUCTION

All of New England was abuzz about the Red Sox in the winter of 1912, and the hot-stove league was fueled by *Boston Globe* writer Tim "Silver King" Murnane and his friends Michael T. "Nuf-Ced" McGreevy and Mayor John F. "Honey-Fitz" Fitzgerald. According to Murnane, baseball slang was the brainchild of sportswriters of the 19th century, who enriched the English language with novel words such as "crank," "rooter," and "fan." With baseball fever in the air, Murnane delivered a lecture on "the Great National Game" at the North Attleboro Knights of Columbus's annual smoker. The most popular part of his discourse regarded the subject of the baseball fan. He described how his colleague Henry Chadwick first coined the phrase "crank" to describe the general baseball enthusiast in 1858, and how his friend Ted Sullivan, in 1884, christened the term "fan."

However, baseball fans could not adequately be defined in such general terms. Murnane felt there was more nuance involved in exposing the true nature of baseball rooters. A "bug," he described, was the species of fan who might "tell you how to run the club and give you free advice on the subject." A "loyal rooter," conversely, was a fan who never said much in public; a fan looked upon by others as a man who knew it all. Murnane described him as "the fellow [who] maintains his silence" and "wears a wise look." The last designation was one Murnane knew well, having experienced firsthand the phenomenon of Boston's "royal rooters."

The royal rooter, although not known for fanatically attending every home game, was willing to travel to root for his team in enemy territory. Murnane, an ex-major-leaguer himself, knew that ballplayers welcomed the presence of royal rooters. He described Boston as the undisputed home of the Royal Rooters, for they played an active role in the World Series of 1903 and would continue to make their mark upon triumphs in 1912, 1915, 1916, and 1918.

The tale of the Royal Rooters is a classic American story featuring sons of Irish immigrants from Roxbury who were smitten with the game of stick and ball first played on Boston Common in the early 19th century. By the 1890s, baseball was a bustling industry, and Boston's entry into the National League gave rise to the Roxbury Rooters, a group of 250 loyal cranks organized under the auspices of saloon keeper Nuf-Ced McGreevy and Congressman Honey-Fitz Fitzgerald, later famous as the grandfather of Pres. John F. Kennedy. For McGreevy, the rooters were good customers at his 3rd Base saloon, and to Fitzgerald, they were loyal supporters at the ballot box.

Many of the rooters who embarked on the first road trip to Baltimore, in the fall of 1897, were part of Boston's Irish political machine. As they cheered captain Hugh Duffy and his men to the pennant, they unknowingly lit a fire of fan frenzy that endures today. They introduced fan-orchestrated bands, megaphones, banners, signs, badges, and buttons, while also establishing the tradition of the baseball road trip. A few years later, their allegiance shifted to the new American League club in town, and they broke new ground as they adopted the popular show

tune "Tessie" as their official fight song. Singing "Tessie" from section J in Pittsburgh during the first World Series, they became as much a part of the game as a fan ever could. The Boston press reported their exploits as if they were actual players, and cartoonists memorialized their antics on the pages of the daily papers, thus, making them stars in their own right. They introduced the sporting public to such figures as "Nuf-Ced," "the Roxbury Kid," "Hi-Hi," "Honey-Fitz," "Cupid," and "Uncle Bill."

The common thread that bound the Rooters together was "Tessie." As a rooter noted in 1903, "Tessie did the trick. Ever since we began to sing that song the boys have played winning ball." Tim Murnane wrote, "she will go tunefully tripping down the ages as the famous mascot that helped the Boston Americans win." In a game wrought with superstition, Boston marched through the first decades of the 20th century as one of the American League's first dynasties. But after six pennants and five world championships to their name, their fortunes changed drastically. By the fall of 1919, with the original Rooters fast becoming old men, "Tessie" was rarely heard at Fenway Park. Babe Ruth was sold to the Yankees, Prohibition closed Nuf-Ced's 3rd Base saloon, Honey-Fitz was indicted for voter fraud, and Royal Rooter Sport Sullivan helped put together the scheme to fix the 1919 World Series at Boston's Hotel Buckminster, just a few blocks from Fenway Park.

Heartbreak and misery for Boston fans ensued for 86 years. Whether one blamed the Curse of the Bambino or poor club management, the result was the same every year. It seemed that without "Tessie" the Red Sox never had a chance. Historian John Holway tabulated the postseason success of the tune between 1901 and 1916: "with Tessie 20-4" and "without Tessie 2-4." In August 1986, before Bill Buckner became a household name, an article was published in the Sox Fan News by Glenn Stout (former curator of the McGreevy Collection at the Boston Public Library) that reminded fans how the Sox had never won without Tessie. He suggested a revival of "Tessie," but no one followed through.

With new ownership of the Red Sox in 2001, Dr. Charles Steinberg was offered a job as the Sox executive vice president from new owner Larry Lucchino. Steinberg, who got his first job in baseball from the grandson of the Baltimore manager who first signed Babe Ruth in 1914 and who ended up giving general manager Theo Epstein his first job in baseball, accepted the offer. The enthused doctor decided to brush up on Sox history and, soon after, picked up Dan Shaughnessy's The Curse of the Bambino. It was the doctor's first encounter with "Tessie."

It was not until the 2003 postseason that Steinberg began toying with the possibility of reintroducing the scratchy c. 1902 version of "Tessie" that he found on the Royal Rooters of Red Sox Nation Web site. He decided not to play the original version at Fenway, thinking it would only assault the ears of fans due to its poor sound quality, and the rest, thanks to Aaron Boone, was 2003 history.

Months later at spring training, Steinberg commiserated with Herald writer Jeff Horrigan to find a group to update the song in 2004. Enter Milton native and maniacal Sox fan Ken Casey, founder of the Boston punk band the Dropkick Murphys, rewrote the song with Horrigan while Steinberg arranged for Red Sox players Johnny Damon, Bronson Arroyo, and Lenny Dinardo to sing backup vocals in the studio. A CD was released, the proceeds going to charity, and the band first performed "Tessie" at Fenway Park on July 24, 2004. Alex Rodriguez (A-Rod) scuffled with Jason Varitek, the slumping Sox turned their season around, and by October, a new generation of Royal Rooters traveled to Anaheim, the Bronx, and St. Louis to cheer the Sox to victory. The ghosts of Lib Dooley, Lolly Hopkins, and every other Sox fan who had passed on without a ring would finally get their title. The Red Sox postseason record with the return of "Tessie" was 12-3. Nuf-ced.

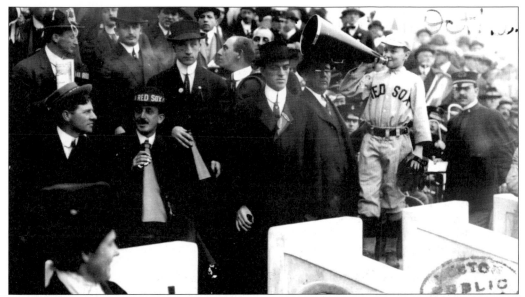

The Royal Rooters, lead by Nuf-Ced McGreevy, adopted the Broadway show tune "Tessie" as Boston's official baseball fight song. During the song's heyday, between 1903 and 1918, the Red Sox won five world championships. In this image, Red Sox batboy Jerry McCarthy serenades the rooters with "Tessie" on one of their megaphones at the 1912 World Series. McCarthy was the envy of every boy in New England and was coaxed into singing "Tessie" at dinners and banquets as well. (Courtesy of the BPL Print Department.)

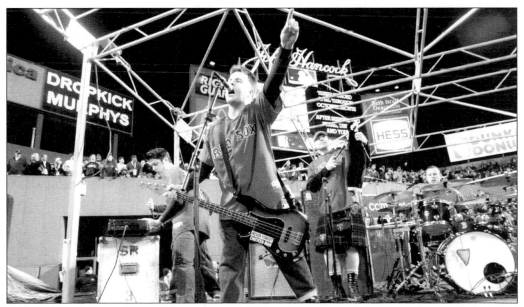

Although "Tessie" made sporadic returns in 1927 and 1930, it was absent for 74 years before Red Sox executive vice president Dr. Charles Steinberg had the idea to revive the Sox fight song. With the help of *Boston Herald* beat baseball writer Jeff Horrigan, Steinberg enlisted Sox fan Ken Casey and his band, the Dropkick Murphys, to revive the old fight song. The band performed "Tessie" at Fenway Park for the first time on July 24, 2004, against the Yankees. (Courtesy of Brita Meng Outzen.)

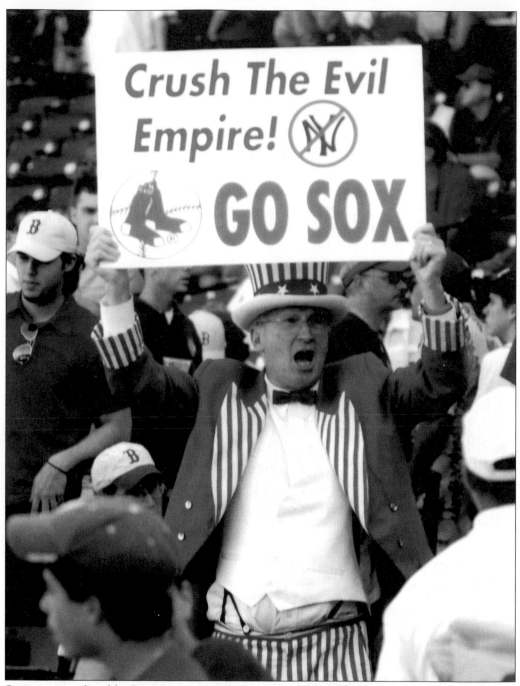

Sign-carrying fans like Boston's own Uncle Sam owe a debt of gratitude to Nuf-Ced McGreevy and his Royal Rooters for their pioneering ingenuity and sign-making prowess that lives on today in the realm of Red Sox Nation. (Courtesy of Brita Meng Outzen.)

One

KRANKS IN THE HUB

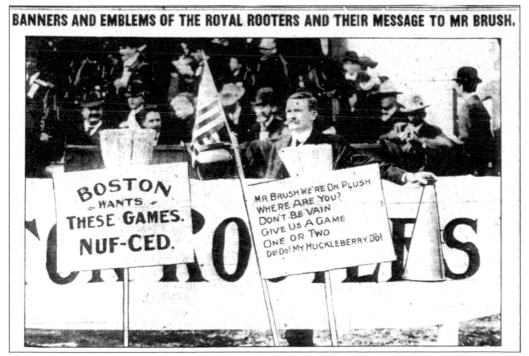

BANNERS AND EMBLEMS OF THE ROYAL ROOTERS AND THEIR MESSAGE TO MR BRUSH.

BOSTON
~ WANTS ~
THESE GAMES.
NUF-CED.

MR BRUSH WE'RE ON PLUSH
WHERE ARE YOU?
DON'T BE VAIN
GIVE US A GAME
ONE OR TWO
Do! Do! MY HUCKLEBERRY. Do!

The undisputed father of Boston baseball fans was Roxbury's own Nuf-Ced McGreevy. A saloon keeper by trade, McGreevy's loyalty to the baseball community set the standard and transformed this conservative baseball town into a "baseball mad" city. Here McGreevy stands at the American League Park in New York to witness the battle for the 1904 pennant on the last day of the season. He was perhaps the first individual fan to revolutionize the baseball sign, which has since become an American ballpark staple. (Courtesy of the BPL Print Department.)

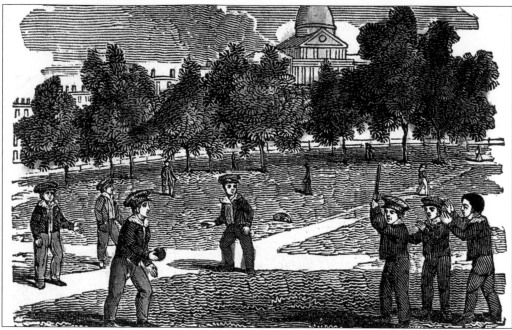

This 1834 woodcut from Robin Carver's *Boy's Own Book of Sports* depicts children playing a game of stick and ball on Boston Common. Boston's first spectators witnessed this primitive version of the game played by children until a more formalized sport made its way to New England in the 1850s. (Courtesy of David Block.)

Nuf-Ced McGreevy continued the tradition of stick and ball as he cultivated the baseball skills of young fans and players on the sandlots of Roxbury. Seated in the center of this studio portrait by the prominent Boston baseball photographer Carl Horner is McGreevy, an accomplished amateur player himself who sponsored youth baseball teams under the Nuf-Ced logo. (Courtesy of the BPL Print Department.)

"TRI-MOUNTAIN" WRITES FOR JOURNAL THE HISTORY OF EARLY BASEBALL IN BOSTON

ntroduction of the National Game in New England—How the First Baseball Diamond was Laid Out—Clubs that Played the First Match Games. | Championship Silver Ball—First Club to Hold It and the Last—What Became of Trophy—Balls Used in Early Games—Where They Are Now.

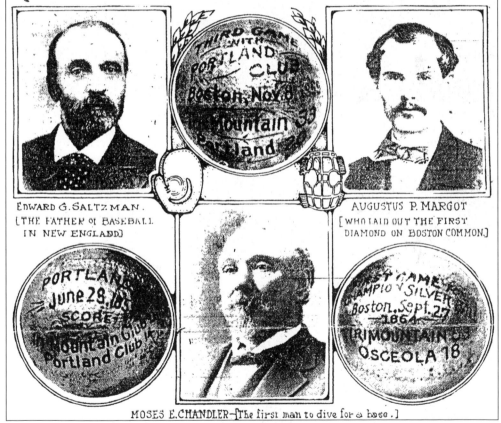

CANE PRESENTED TO MOSES E. CHANDLER BY R. A. NICHOLAS OF THE TRI-MOUNTAIN CLUB.

EDWARD G. SALTZMAN. [THE FATHER OF BASEBALL IN NEW ENGLAND]

AUGUSTUS P. MARGOT [WHO LAID OUT THE FIRST DIAMOND ON BOSTON COMMON.]

MOSES E. CHANDLER—[The first man to dive for a base.]

In the mid-19th century, an early form of baseball known as the Massachusetts Game was popular with New Englanders. New Yorker Edward G. Saltzman (former second baseman of New York's Gotham Base Ball Club) first introduced the New York Game on Boston Common. He moved to Boston to work for a watchcase engraver, and on June 17, 1857, his newly formed Tri-Mountain Club played their first match game in front of spectators who were not fans of the new game. One Tri-Mountain player recalled how the interest of onlookers to the first games was "manifested by jeers . . . and other types of annoyances which, [were] the sort of treatment we endured for the first two years of our struggle." The above item appeared in the *Boston Journal* in 1905, when arguments over baseball's origins were quite prevalent.

13

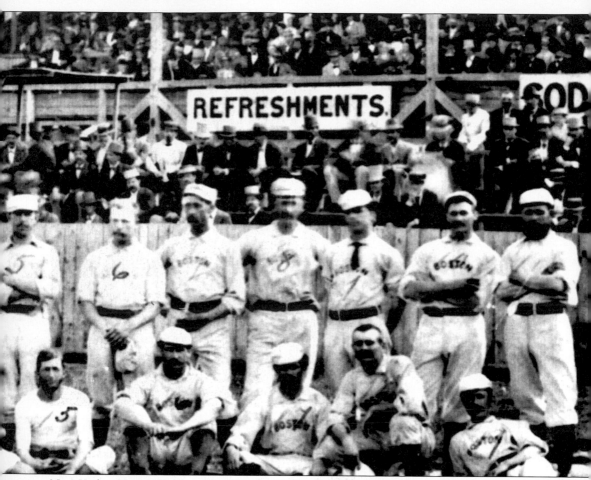

New Yorker Harry Wright played for the Gothams of New York City in the 1850s and led the Cincinnati Red Stockings to an undefeated record in 1869. With their first defeat, however, the city lost interest in their team, and Wright, a shrewd businessman, moved his baseball operations and formed the Boston Red Stockings of the fledgling National Association. This image captures Wright's team, along with the Philadelphia Athletics, at the Boston Grounds in 1875. Under Wright's watch, the franchise was a financial success. This image illustrates some of the earliest photographic evidence of baseball commerce geared toward the paying customer. The seated "cranks," as they were known, sit in wooden bleachers in front of the earliest of concession signs. (Courtesy of the BPL Print Department.)

Gen. Arthur "Hi-Hi" Dixwell (center), a noted "trust fund child," was Boston's first celebrity fan. He showered his favorite Boston players with gifts of cigars, jewelry, walking sticks, and trophies. Always quotable in the Boston papers, he once said of bowlegged pitcher Tim Keefe, "What manner of man is this, who carries his balls in parenthesis?" (Courtesy of the BPL Print Department.)

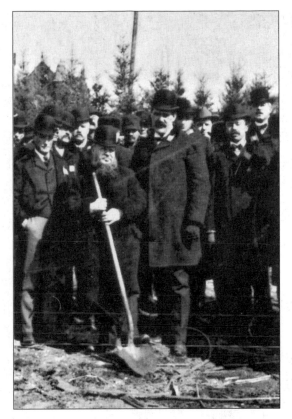

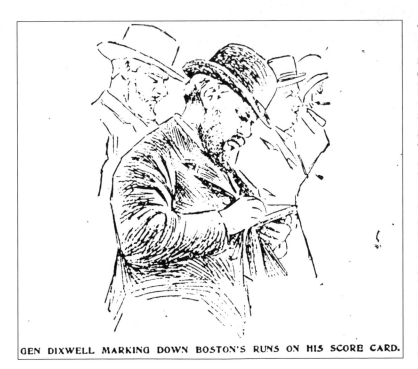

GEN DIXWELL MARKING DOWN BOSTON'S RUNS ON HIS SCORE CARD.

The portly General Dixwell was a fixture at the South End Grounds and was known to occupy the same three seats for each game so he could sit comfortably. This *Boston Globe* woodcut shows him following each movement on the field with scorecards provided by young hawkers for a nickel. An early statistics junkie, the general was known to transcribe his own league averages throughout the season. (Courtesy of Carroll Tenney.)

15

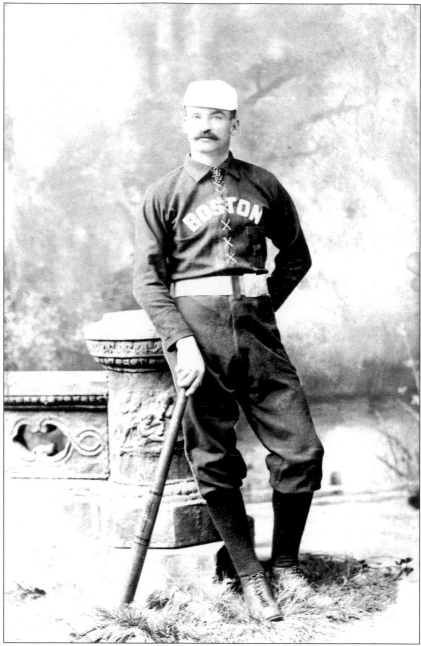

Michael "King" Kelly was Boston's first baseball idol. He was flamboyant both on the field and off and captivated the hearts of Hub fans. His base stealing was legendary and inspired the phrase "slide, Kelly slide," which later became a song title. In the *Boston Globe*, Tim Murnane substituted Kelly's name for Casey in Ernest Lawrence Thayer's "Casey at the Bat." Legend has it that Kelly was one of the first players to scrawl his name on paper as an autograph for his adoring fans. In 1888, with the aid of Murnane, he penned baseball's first player autobiography, *Play Ball: Stories of the Diamond Field*, which was dedicated to the fans. Still a fan favorite after he left Boston to play for Cincinnati in 1891, he was presented with a handsome carriage as a gift from the Boston cranks.

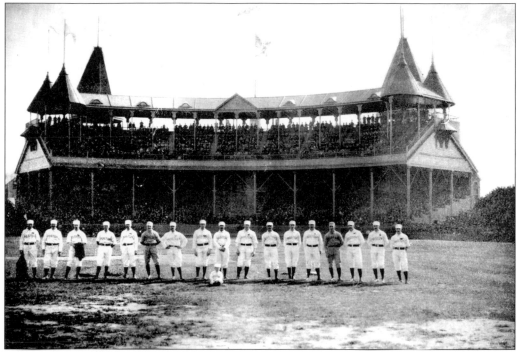

Boston's first baseball palace was the Walpole Street, or South End, Grounds, which featured a grand pavilion designed by architect John J. Deery. This image shows opening day on April 25, 1888. In addition to heavyweight champion John L. Sullivan, a veritable who's who of Boston politicians attended the game, including Gov. Oliver Ames and John F. Fitzgerald. The Boston cranks were entertained by J. Thomas Baldwin's 30-piece cadet band that played a special march "They'll Get There," dedicated by Baldwin to the 1888 Boston team. (Courtesy of the National Baseball Hall of Fame Library, Cooperstown, New York.)

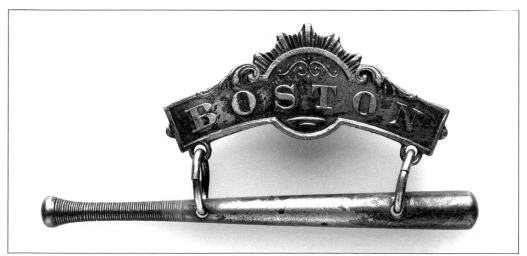

This silver Boston Rooters badge features a finely crafted 1880s baseball bat that shows intricate detail down to the twine wrapped around its handle. Perhaps one of the earliest badges of its kind, fan emblems like this one would soon become a part of Boston baseball tradition as fans reveled in showing their public allegiance to the hometown club.

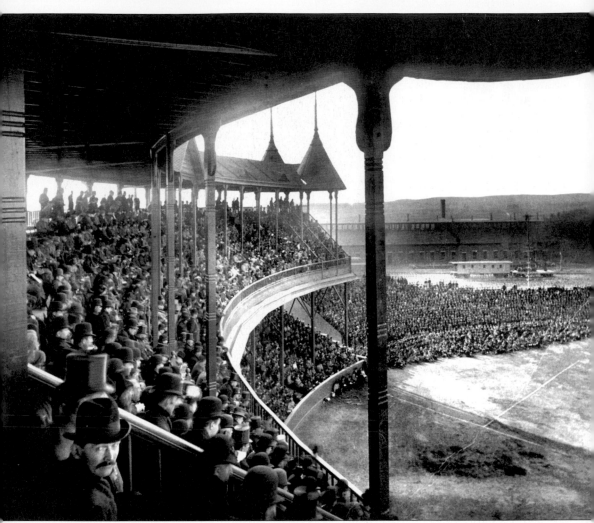

Only one fan seated in the Grand Pavilion has taken his eye off the ball in this photograph taken at the grand opening of the South End Grounds. Close to 13,000 Boston fans attended the historic first game in 1888. The ballpark, with its ornate witch's hat pavilion, was considered the finest in the nation up to the point it caught fire during the third inning of a game against Baltimore on May 14, 1894. Rooters seated in the right field bleachers scurried to safety as the wooden structure caught fire, and despite attempts by players to extinguish the initial flames, the fire enveloped the entire park. All was lost except for a handful of team photographs in the clubhouse saved by *Boston Globe* writer Tim Murnane. (Courtesy of the National Baseball Hall of Fame Library, Cooperstown, New York.)

Vying for the title of most rabid New England fan in the 19th century was wealthy financier Thomas W. Lawson. In 1884, he created a card game he called "Lawson's Patent Game of Base Ball with Cards" and sold it at ballparks and train stations. Like General Dixwell, he showered his favorite players with trophies and jewelry and rooted fiercely for Boston well into the 20th century. He also headed the Amalgamated Copper Company and is known better as the author of *Frenzied Finance*, an exposé on Wall Street stock manipulation and crookedness. (Courtesy of the BPL Print Department.)

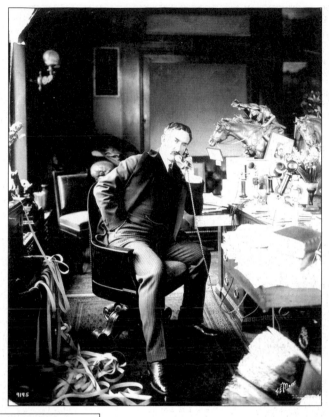

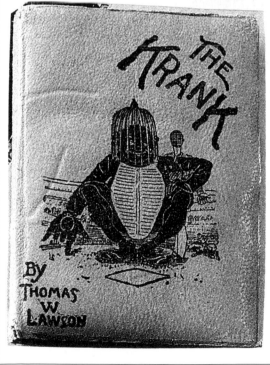

In 1888, Lawson released a comical handbook of prose and poetry entitled *The Krank: His Language and What It Means*, describing a typical day at the park for a 19th-century fan, as well as defining baseball slang. A died-in-the-wool fan, Lawson wrote of how the use of a scorecard at a game would "distinguish the advanced Krank from the Krank who has not yet graduated." (Courtesy of the National Baseball Hall of Fame Library, Cooperstown, New York.)

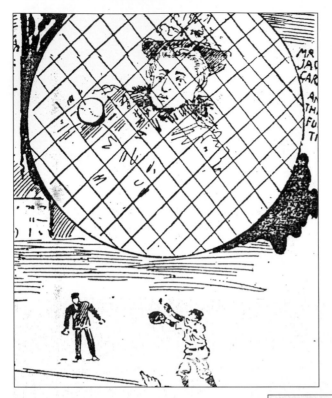

Boston baseball's first lady was Lucy Swift of New Bedford, seen here. In her signature black dress and holding her tiny black score book, she attended amateur and professional games, sometimes four or five times a week, for close to 65 years dating back to the early 1880s. In 1905, she moved to Trinity Court in Boston and religiously rooted for the Braves and Sox. She rooted for players like King Kelly, her all time favorite Fred Tenney, and Jimmy Foxx up to the time of her death in 1943.

Boston furniture wholesaler Michael J. Regan was called "the undisputed champion baseball rooter of the world" by the *Sporting News*. In the late 19th century, he was a friend of magnates and players and an honorary member of the National Association. He became a prominent Royal Rooter along with Nuf-Ced McGreevy and was a regular on road trips. His usual seat at the park was near the center of the grandstand; however, Regan usually circulated amongst his fellow Rooters. (Courtesy of the National Baseball Hall of Fame Library, Cooperstown, New York.)

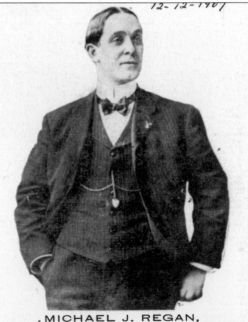

. MICHAEL J. REGAN,

Undisputed champion base ball rooter of the world, is as appreciative of the minor league as of the major league brand of his favorite sport, knows more ball players, magnates and patrons than any other six men in the country and numbers all of them as his friends. Mike adopted the policy of neutrality throughout the major league war and has been strictly non-partisan during the peace period. He hobnobs with the major league mogule at their meetings and mingles with the minor league magnates at sessions of the National Association, of which he is an honorary member. He has since his youth been identified with one of the largest wholesale furniture establishments in the country, with headquarters at Boston and as the organizer and chief of its army of traveling salesmen draws salary that enables him to live well and star in the role of good fellow. As a raconteur he is in a class by himself and no one in good standing in base ball ever asked for Mike's aid or advice that did not get it—and then some.

Two

THE ROXBURY ROOTERS

In September 1897, the Beaneaters battled Baltimore's Orioles for the National League pennant. Boston fans traveled to Baltimore by rail to support their team. Boston took the first game, and before the second game, the fans posed with the team in front of Baltimore's Eutaw Hotel. Booked at the hotel with their heroes, the Roxbury Rooters were led by Congressman John F. "Honey-Fitz" Fitzgerald (seated at center of the team). Honey-Fitz led the Rooters on a tour of the capital and hired a band (pictured above on the balcony) to accompany them for both the tour and the second game. The superstitious Boston player Billy Hamilton blamed this group photograph for the club's only loss of the series later that day. The Rooters, however, with their badges, horns, and rattles ultimately were credited by many with playing a key role in the victorious rubber game on September 26. (Courtesy of the BPL Print Department.)

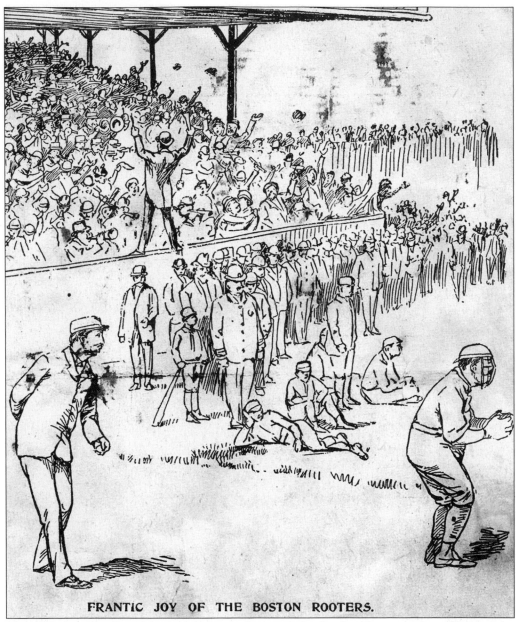

FRANTIC JOY OF THE BOSTON ROOTERS.

This 1897 woodcut illustrates the Rooters as they overtake the third-base grandstand behind the Boston players' bench during the deciding third game. The *Boston Globe* commented, "It will undoubtedly seem strange to the Boston players to have any one 'root' for them on the grounds of their rivals, but the 125 local and suburban 'rooters' . . . are capable of holding their end up when it comes to 'rooting.'" This was the birth of baseball's "10th man." Under McGreevy's lead, they cheered loudly: "Boston, Boston, Rah, Rah, Rah; Rocket racket, Siz boom, whiz; Champions, Champions, Her dey is!"

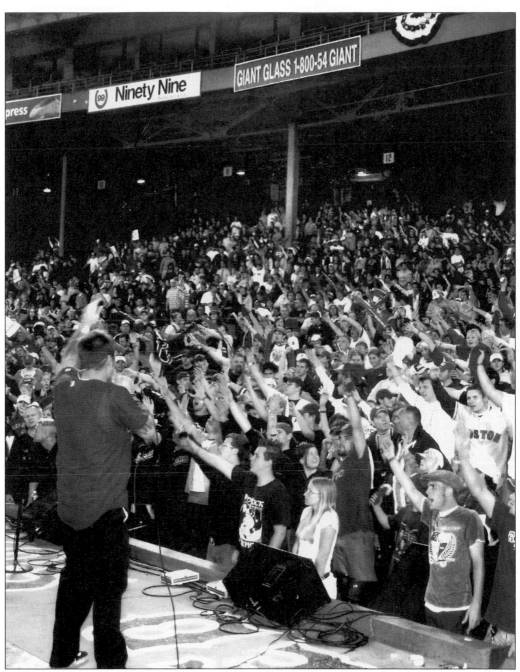

In an almost mirror image of the opposite 1897 illustration, the modern Boston band the Dropkick Murphys leads cheers at a Fenway Park rally in the postseason of 2004. What the Roxbury Rooters started innocently back in 1897 has become a Boston tradition that endures over 100 years later. (Courtesy of Grant Thayer.)

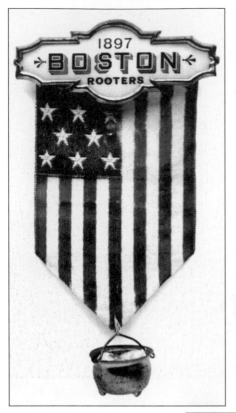

Catering to readers who were baseball fans, a Boston newspaper produced these impressive Rooters badges to distribute amongst the Bostonians traveling to Baltimore. Perhaps the only surviving specimen known, this badge has been on display at the National Baseball Hall of Fame and, fittingly, has also been a part of their traveling exhibitions. (Courtesy of the National Baseball Hall of Fame Library, Cooperstown, New York.)

This woodcut shows the Royal Rooters departing for Baltimore at the Boston train station. Fellow Rooter and train conductor W. R. Rich of Haverhill, Massachusetts, made arrangements for over 130 rooters to make the trip south, which also included steamship travel. (Courtesy of Carroll Tenney.)

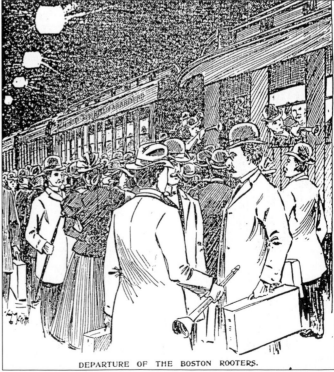

DEPARTURE OF THE BOSTON ROOTERS.

The traveling party was organized by both Nuf-Ced McGreevy and Congressman John F. Fitzgerald. Honey-Fitz, as he was nicknamed, by all accounts was a true crank who gave his heart and soul to the pilgrimage as a Boston Royal Rooter. Player Fred Tenney remembered Honey-Fitz leading cheers, "Hit her up, hit her up, hit her up again, for B-O-S-T-O-N." A true fan, he was called "an avid scorer of games" by the *Sporting Life*.

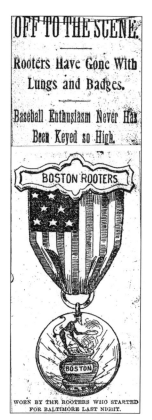

The *Boston Globe* produced the badge illustrated here specifically for the Rooters on the excursion of 1897. Its enameled medallion depicted a bean pot topped by "old Satan, politely bowing, hat in hand, as if in mockery of the attempt of the Baltimores to beat the Bostons."

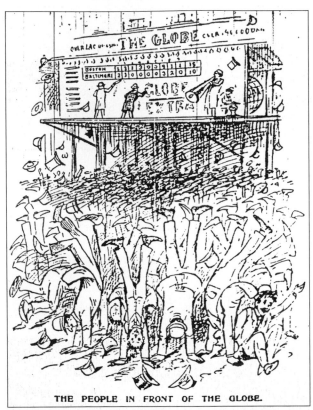

THE PEOPLE IN FRONT OF THE GLOBE.

Fans unable to join the Roxbury Rooters followed the action in Baltimore on a scoreboard in front of the *Boston Globe* building. Telegraph dispatches were delivered to attendants who transferred scores onto slate boards, much to the approval of the hysterical fans illustrated here. The *Sporting Life* reported over 10,000 fans gathered on Newspaper Row.

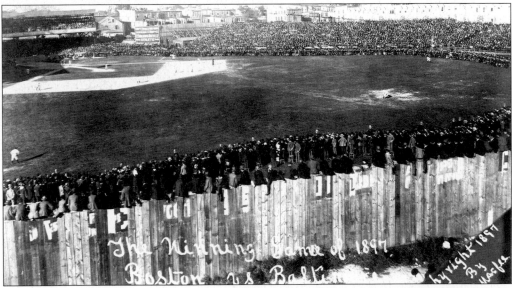

This image shows Baltimore's Union Park as it looked on the day of the pennant-deciding game on September 27, 1897. Reserved seats were sold at 75¢ each, and the Roxbury Rooters had a section of their own reserved in the grandstand. During the hotly contested series, local police used ropes and extra manpower to combat overflow crowds that ultimately broke through and rushed on the field. It was the crowning day for the Rooters, solidifying their place as a force opponents had to reckon with.

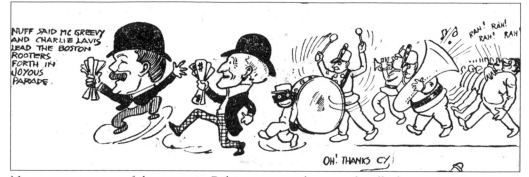

Newspaper coverage of the games in Baltimore created a groundswell of interest amongst even the most casual Boston fans. The coverage of the Roxbury Rooters and their antics at the ballpark made them local celebrities. The competing news outlets in Boston from that time forward regularly featured caricatures like this one of popular fans such as Nuf-Ced McGreevy and Charlie Lavis, seen above.

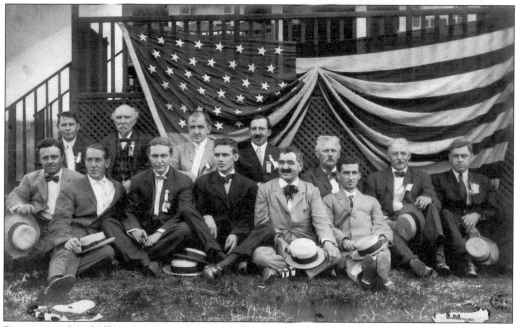

Beantown's baseball press corps is pictured above at a 1908 Old-Timers Day at Peddock's Island in Boston Harbor. Numerous papers competed for the Boston fans' business, including the *Boston Globe, Herald, Transcript,* and *Post and Journal.* Tim Murnane of the *Globe* (second from the right, back row) and Jacob Morse of the *Herald* (second from the right, front row) were leading columnists and chronicled the impact that the Royal Rooters had upon the games they attended. (Courtesy of the BPL Print Department.)

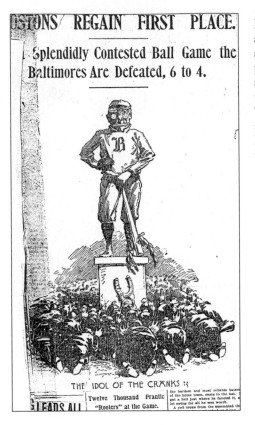

OSTONS REGAIN FIRST PLACE.

Splendidly Contested Ball Game the Baltimores Are Defeated, 6 to 4.

THE IDOL OF THE CRANKS :;

Twelve Thousand Frantic "Rooters" at the Game.

LEADS ALL

Fred Tenney became the "Idol of the Cranks" with a dramatic game-winning hit against Baltimore at the South End Grounds during the late season pennant drive. The crowd of Rooters cheered as he drove in three runs and then swarmed the field and seized him. The Rooters chanted, "Three times three for Tenney!" and made him an honorary Knight of the Order of Rooters. The Rooters bow in deference to his greatness in this woodcut. (Courtesy of Carroll Tenney.)

Tenney was one of the first players ever to be lifted up over the shoulders of fans and hoisted up into the grandstand. This woodcut illustrates the fan frenzy that prompted newspaper men to say, "Never was there such cheering at a professional base ball game." It was evidence that the city was truly fanatical about baseball and a catalyst promoting the Roxbury Rooters' decision to travel to Baltimore. (Courtesy of Carroll Tenney.)

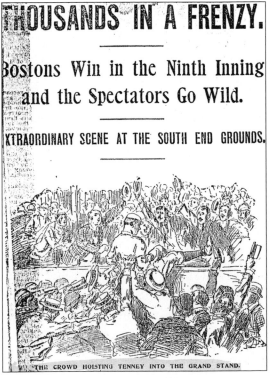

THOUSANDS IN A FRENZY.

Bostons Win in the Ninth Inning and the Spectators Go Wild.

XTRAORDINARY SCENE AT THE SOUTH END GROUNDS.

THE CROWD HOISTING TENNEY INTO THE GRAND STAND.

On October 6, 1897, the champions were honored at Boston's Faneuil Hall. John F. Fitzgerald organized the banquet and served as its toastmaster along with his fellow fans that the *Sporting Life* called "the immortal 200 rooters." With the hall decorated in patriotic bunting and a silk pennant proclaiming "Champions of 1898," Honey-Fitz proclaimed, "The rooters are here to testify to their devotion to the club and to the manner in which the club played during the past season."

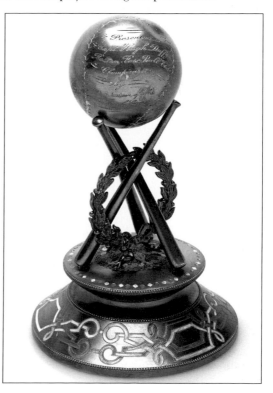

Boston team captain Hugh Duffy, holder of the game's highest single-season batting average of .438 in 1894, was presented with this ornate silver trophy by Congressman Fitzgerald that evening. It was engraved from "An admirer of the National Game" to commemorate the championship of 1897. The Rooters also furnished Fitzgerald with gold stickpins to present to each player amidst the wild applause of fans, politicians, and even hall of famer Joe Kelley of the defeated rival Orioles.

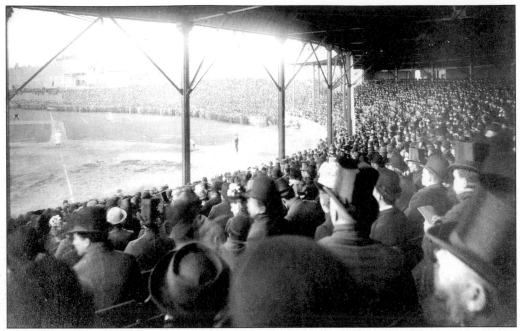

This bird's-eye view of the South End Grounds was available to top-hatted rooters who purchased the more expensive grandstand tickets around 1888. The fire of 1894 gave rise to a second South End Grounds, and the advent of the American League in 1901 provided the Rooters with another outlet to attend ball games. (Courtesy of the National Baseball Hall of Fame Library, Cooperstown, New York.)

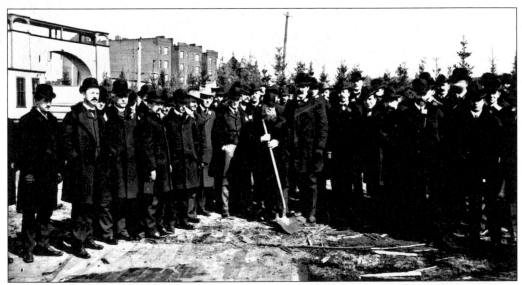

The ground-breaking ceremony for the new Huntington Avenue Grounds took place on March 12, 1901. Doing the honors with the shovel was senior crank Hi-Hi Dixwell with Royal Rooters Charlie Lavis (second to the left of Dixwell), Nuf-Ced McGreevy (holding a "Brownie" box camera), and Mike Sullivan (former player and state senator) looking on. McGreevy later donated this photograph to the Boston Public Library, who described in their bulletin that "turning the first spadeful of earth" was a "solemn rite." (Courtesy of the BPL Print Department.)

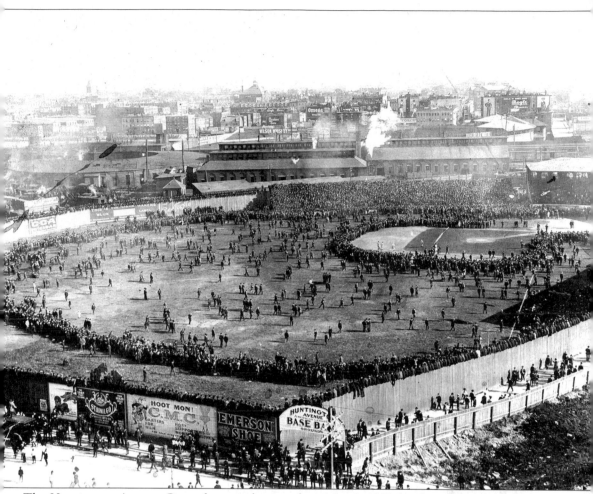

The Huntington Avenue Grounds were christened on May 8, 1901, by the newly established Boston club of Ban Johnson's new American League. The Royal Rooters, longtime supporters of the National League franchise in town, soon gave their allegiance to the fledgling Americans after an imbroglio over National League ticket prices. The Americans also featured the revered former Beaneater and rooter favorite, third baseman Jimmy Collins, which made their shift of allegiance quite palpable. This image captures the scene of rooters circulating upon the field before the first game of the 1903 World Series.

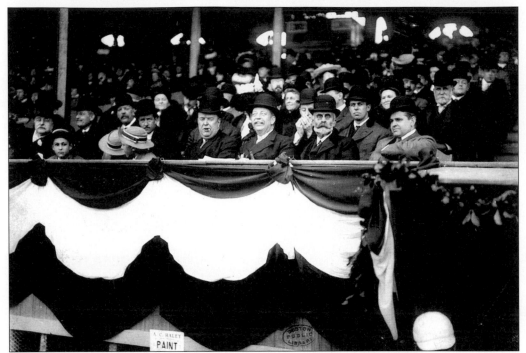

Ban Johnson (with cigar in mouth) looked upon Boston as a key market for his upstart American League's direct competition with the long-established National League. Henry Killilea was the team's second owner until *Boston Globe* owner and avid fan Gen. Charles H. Taylor (second from right) bought him out with Johnson's approval. Taylor's paper was fan friendly, featuring the lucid musings of ex-Boston player Tim Murnane. Taylor was called the "fan of fans" and helped elevate the game's profile in the news for fellow cranks. (Courtesy of the BPL Print Department.)

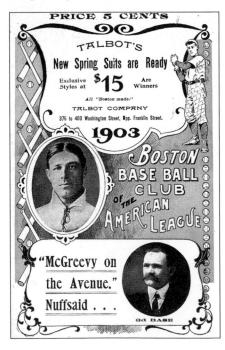

The Boston American League franchise survived financially with the support of loyal fans like the Royal Rooters. Nuf-Ced McGreevy also furthered his own cause by buying advertising space for his watering hole, 3rd Base saloon, on the ballpark's scorecards and outfield walls. He is paired with another grand third baseman, hall of famer Jimmy Collins, on this 1903 scorecard once owned by an original Royal Rooter.

Three

3RD BASE: NUF-CED

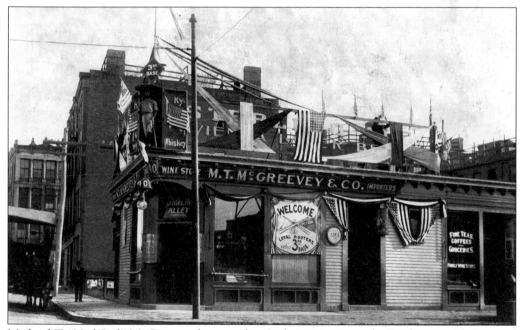

Michael T. "Nuf-Ced" McGreevy, the son of an Irish immigrant and a Roxbury native, opened his first tavern in 1894. He was short and muscular with a handlebar mustache, and he ended any argument with his fist tapping the bar and a shout of "nuf-ced." In 1900, he moved his operation close to the Huntington Avenue Grounds at 940 Columbus Avenue. Politicians, gamblers, and baseball stars rubbed elbows in the saloon that looked like a baseball shrine inside. In October 1903, during his return from the World Series in Pittsburgh, friends (like the man pictured here on the roof) surprised Nuf-Ced by decorating the bar with patriotic bunting and American flags, with a freshly painted sign that read "Welcome Loyal Rooters, Pittsburg and Boston, 3rd Base, Nuff-Said." McGreevy aptly advertised his establishment as "3rd Base, the last stop before you go home." The life-size mannequin perched above the saloon entrance was known simply as the "Baseball Man."

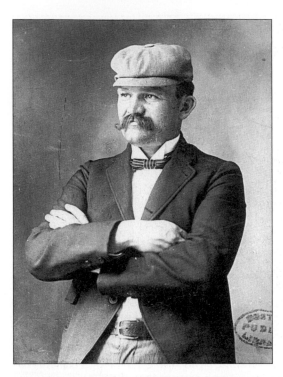

Nuf-Ced McGreevy was, perhaps, the most influential baseball fan of all time. He was a student of the game and a close friend of his era's current and old-time stars. He had no love for the "hanger on" prone to hero worship, who he considered, "the worst pest in the family of fans." He was an insider, respected by the baseball fraternity, and a leader amongst the fans he served in his 3rd Base saloon. Oddly enough, his granddaughter remembers how saloon keeper McGreevy prided himself on never touching a drop of alcohol himself. (Courtesy of the BPL Print Department.)

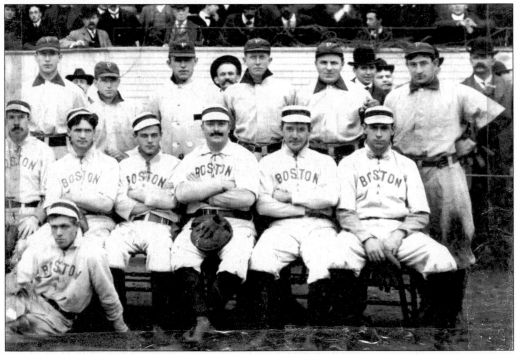

Nuf-Ced was virtually everywhere. He sneaked into this posed shot of both 1903 Boston and Pittsburgh teams before the final game of the first World Series at the Huntington Avenue Grounds (back row, fourth from the right). The great Honus Wagner appears standing to the far right.

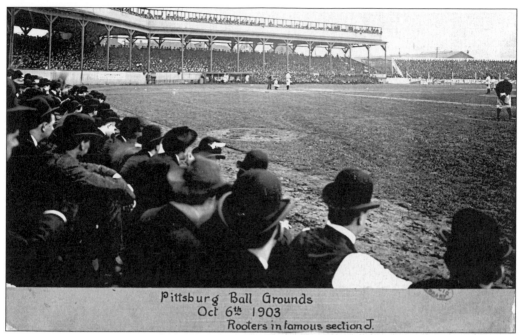

Pittsburg Ball Grounds
Oct 6th 1903
Rooters in famous section J.

Nuf-Ced mobilized the Royal Rooters and arranged for travel by rail to Pittsburgh for games four through seven of the 1903 World Series. At the Pittsburgh ballpark, the rooters occupied what became known as the famous Section J. In the ninth inning of game four, the "Tessie" sensation was born. Nuf-Ced, Charlie Lavis, and their fellow rooters sang their fight song from their seats on the first-base line (above). The Boston team rallied with the aid of "Tessie" in the ninth but fell short, losing 5-4. (Courtesy of the BPL Print Department.)

Nuf-Ced printed "Tessie" song cards with the original lyrics after game four in Pittsburgh. A century later, "Tessie" returned to Beantown in the form of this CD released by renowned Boston punk band, the Dropkick Murphys. The 2004 lyrics paid homage to the Royal Rooters as they sang, "Tessie is the Royal Rooters rally cry, Tessie is the tune they always sung." (Courtesy of the Dropkick Murphys.)

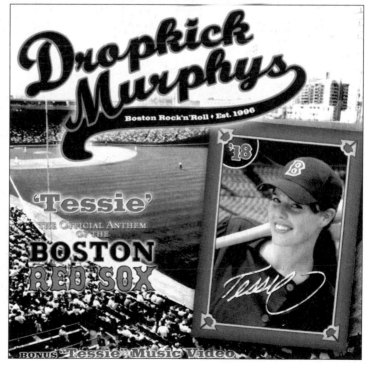

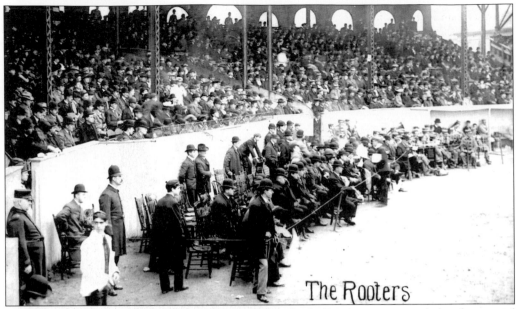

On their home turf at the Huntington Avenue Grounds, the Rooters were provided with a special field level section replete with wooden chairs. Their close proximity to the action prompted Pittsburgh star Tommy Leach to later recall, "I think those Boston fans actually won that series for the Red Sox . . . you could hardly play ball they were singing 'Tessie' so loud." (Courtesy of the BPL Print Department.)

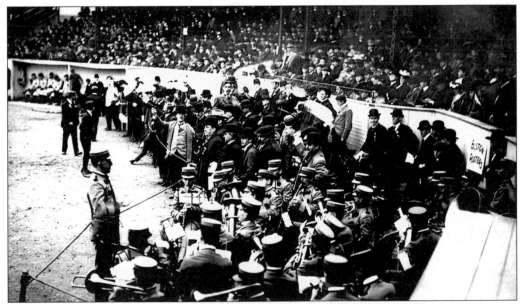

The 35-piece Boston Letter Carriers Band joined the rooters in a special section behind home plate. Here they strike up the war cry of "Tessie" during the eighth and deciding game in Boston. The rooters hired the services of the Guenther Band of Pittsburgh to back them up during game four. They secured a different band for game five, inviting a breach of contract suit and a legal scuffle in the Pittsburgh courts—during the World Series—over $285. (Courtesy of the BPL Print Department.)

Another founding member of the Royal Rooters was the energetic and vociferous Louis Watson, who toted around an American flag and a symbolic bean pot attached to a broomstick. (Courtesy of the BPL Print Department.)

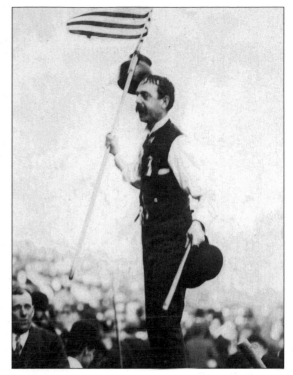

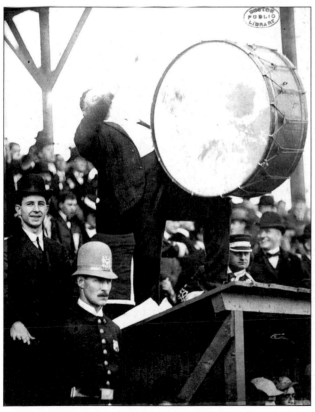

The Rooters traveled with this large bass drum to provide additional rhythmic accompaniment for their war cries. They would influence all future baseball bands, in particular the Brooklyn Dodger Sym-Phony Band that later featured its own signature bass drum. (Courtesy of the BPL Print Department.)

37

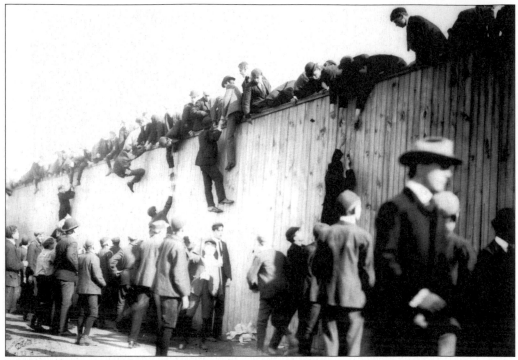

Sold-out crowds throughout the World Series forced die-hard Royal Rooters to figure out alternative methods to gain entrance to the grounds. (Courtesy of the BPL Print Department.)

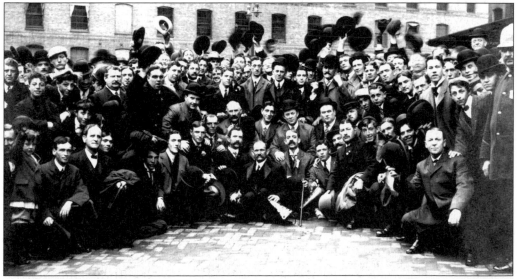

Nuf-Ced (center with megaphone) holds court with Jerry Watson (to his right) at Boston's South Station upon the return of fans from Pittsburgh after game seven. Former Boston Public Library curator of the McGreevy Collection, Glenn Stout, noted in his photo research how Nuf-Ced has a fistful of dollar bills in his hand, "undoubtedly a reference to the Rooters recent success in gambling on the World Series." The game's integrity was tested regularly due to wagering at the ballpark as rumors abounded that the 1903 World Series was not on the level. Royal Rooter Sport Sullivan was rumored to have won more than $20,000 on the series. (Courtesy of the BPL Print Department.)

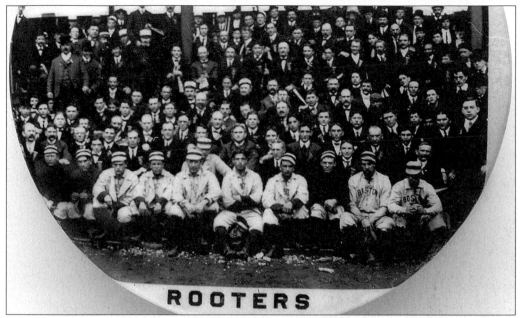

ROOTERS

After the triumph of "Tessie" in game seven, Nuf-Ced commissioned Pittsburgh photographer D. Rosser to capture this image of the rooters of Section J and the soon-to-be world champion Boston Americans. A large print of the image was purchased by McGreevy to hang in 3rd Base, while he also placed an order to put the image on celluloid photographic buttons as souvenirs for his fellow rooters. Over a century later, this button and a handful of others are the only surviving specimens of Nuf-Ced's original order.

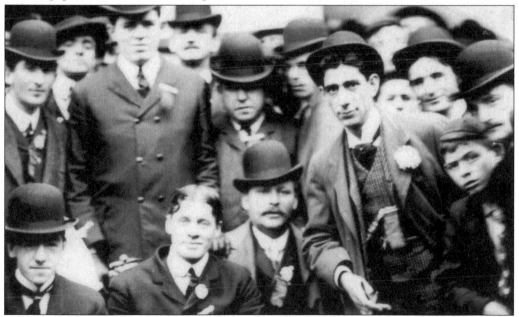

The Rooters return to Boston from Pittsburgh proudly displaying their new photographic buttons and silk ribbons for the local press. Charles Lavis is the rooter in the top row, far left. The Rooters' obsession with the team-related trinkets they wore laid the foundation for the future bonanza of Boston Red Sox souvenirs. (Courtesy of the BPL Print Department.)

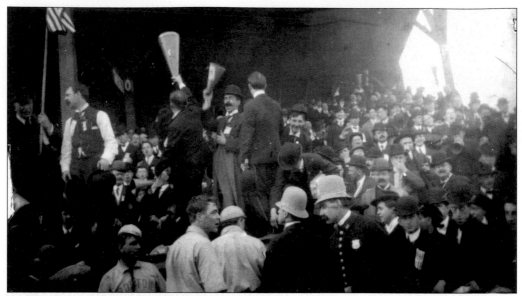

The Royal Rooters' involvement in the actual course of a game is evident in this rare image from the end of the 1904 season. After their victory in the 1903 World Series, Boston battled New York in a tight 1904 pennant race that was decided on the last road trip of the season in New York. The Rooters outdid themselves, as Nuf-Ced and Jerry Watson led the war cry from atop the Boston dugout. (Courtesy of the BPL Print Department.)

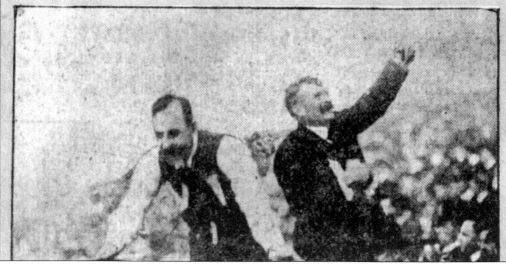

The Boston papers reported the exploits of the Rooters with great interest. In this report to fans back home, McGreevy and Watson are elevated to icon status among Rooters. (Courtesy of the BPL Print Department.)

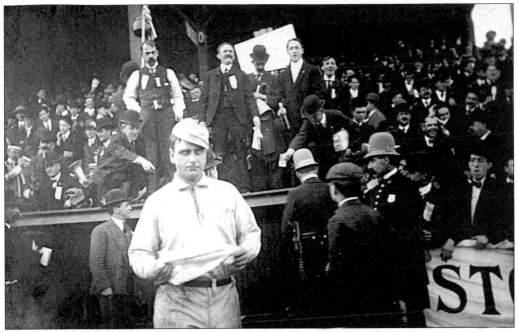

Waving flags, bean pots, banners, megaphones, and a clever homemade sign, Nuf-Ced, Jerry Watson, and company lead the faithful with the cry of "Tessie" as Boston player Chick Stahl makes his way out of the visiting dugout. The largest contingent of Boston Royal Rooters is seen to the left of the dugout on the third-base line where the front row fans hung long Boston Rooters banners along the ballpark fence. Note the Rooter placing a beer glass down on the dugout. (Courtesy of the BPL Print Department.)

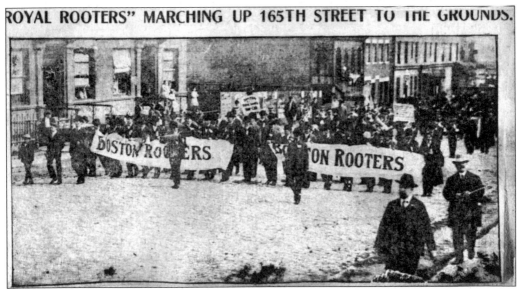

Upon their arrival in New York City, the Rooters announced their presence as they unfurled these 20-foot-long, painted parade banners and marched up 165th Street toward the New York club's American League park. (Courtesy of the BPL Print Department.)

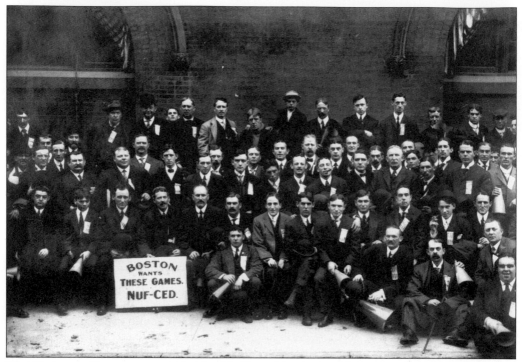

The Rooters strike a pose outside the Marlboro Hotel upon their arrival in New York City. Seated to the far right (front) is C. F. Madden, better known as the "Roxbury Kid." To his immediate left (seated) are Jerry Watson and Nuf-Ced, holding his signature megaphone. Their sign signifies the do-or-die nature of the pennant-deciding series. In fact, before the American League Championship Series victory in 2004, it was the last time Boston beat New York in a winner-take-all situation. (Courtesy of the BPL Print Department.)

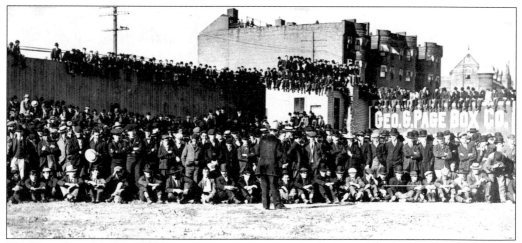

The Huntington Avenue Grounds hosted this capacity crowd on September 16, 1904, where fans witnessed a pennant race battle between Boston and the New York Americans. An overflow of rooters prompted standing room only sections in the outfield, separated from the action with a mere rope. Female rooters were admitted free of charge to the grounds thanks to the club's Ladies Day offering. (Courtesy of the BPL Print Department.)

Fund For Capt. Collins Loving Cup Has Already Passed $100 Mark

M.T. Mc GREEVY

Sporting Editor Boston Journal —
Enclosed find check for $6.
Just like Charlie Lavis, a
good suggestion at the right
time and with Boston Journal
to push it along, it will be
a crack a jack. *Nuf Ced*

As the 1904 season wound down in a tight pennant race between New York and Boston, Charlie Lavis wrote a letter to the *Boston Journal* suggesting that the fans of Boston donate funds to commission a large silver cup for their team captain and star Jimmy Collins. Fellow Rooters began sending in cash gifts ranging from Nuf-Ced's $5 to 1¢. The paper covered the daily contributions like a line score for a ballgame. Michael Regan, Nuf-Ced, Johnny Keenan, Hubert Curley, and John Noonan served as the "Journal Cup" committee. (Courtesy of the BPL Print Department.)

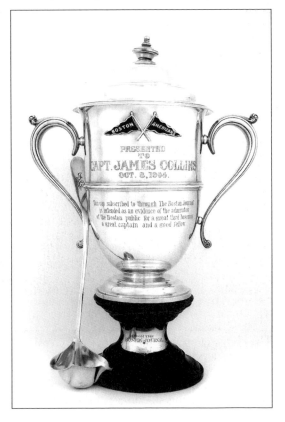

The trophy created by A. Stowell and Company was a silver loving cup with a ladle. The rooter donations had topped $280, and on October 7, 1904, before the game, fans witnessed Lavis delivering the cup to Collins, who stood at home plate. He gave a heartfelt speech and presented the cup to the captain. The fans hoped the cup would act as a mascot and bring home the pennant. It did just that.

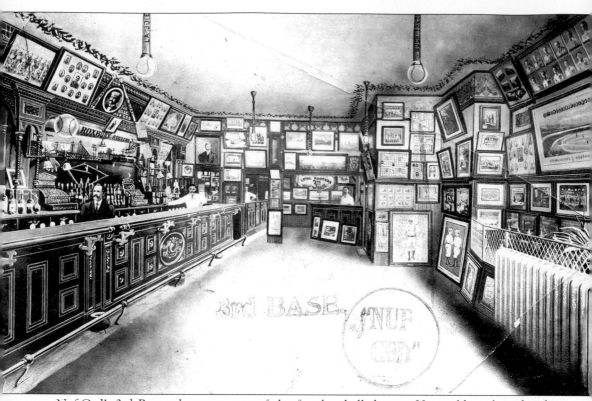

Nuf-Ced's 3rd Base saloon was one of the first baseball shrines. He could easily stake claim as baseball's first obsessive memorabilia collector. Hanging from the ceiling were actual game bats from the likes of Nap Lajoie, Buck Freeman, and Cy Young, which were transformed into electric lighting fixtures attached to frosted glass spheres made to resemble baseballs. He made trips to other cities to secure new photographs to adorn the walls and received gracious gifts from players and fans. This image, which shows Nuf-Ced behind the bar, appeared on a *c.* 1906 real-photo postcard Nuf-Ced sent out. One of his original bartenders, Tom Kenney (later known as the Fenway Park "attaché"), recalled how the bar was strategically located, as it was impossible to go to the American League or National League grounds without confronting 3rd Base. The saloon was a popular stop for coach drivers because Nuf-Ced served pickles to their horses. (Courtesy of John Kashmanian.)

Four

"TESSIE" TAKES BROADWAY

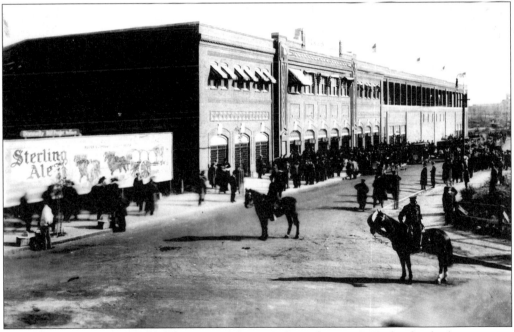

The Red Sox were aptly named by owner John I. Taylor in late 1907. Taylor first had aspirations for a new stadium in 1910, when he decided not to renew the lease on the Huntington Avenue Grounds. By June 24, 1911, the *Boston Globe* announced that the club would build a new stadium. Located in the Fenway section of the city, the land was owned by the Taylor family who, according to writer Dan Shaughnessy, named the park to promote their company, the Fenway Realty Company. This image shows Fenway's exterior in 1912. (Courtesy of the National Baseball Hall of Fame Library, Cooperstown, New York.)

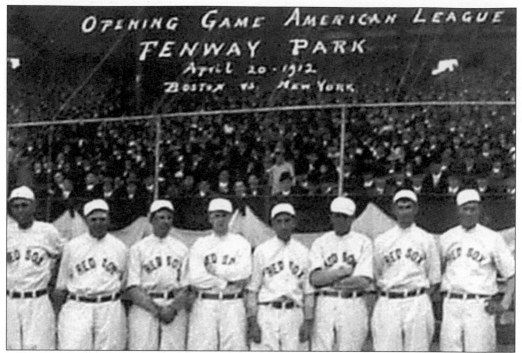

This image is taken from an original panoramic photograph of the first major-league ballgame at Fenway Park on April 20, 1912. Fittingly, the Red Sox's opponent was the Highlanders of New York, who later became their modern-day rival, the Yankees. The Rooters were quite anxious, as the opening date had been pushed back a few days due to rainouts. The Sox began their winning tradition, beating the New York club 7-6 in 11 innings, getting little notice in the local papers due to the sinking of the *Titanic*.

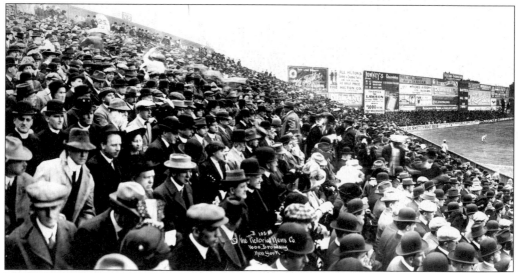

The Red Sox wasted no time bringing postseason baseball to their newly built ballpark as they captured the pennant and faced off against John McGraw's New York Giants for the ninth World Series. This image shows the sold-out game two at Fenway with the Boston crowd sporting an assortment of period head wear. (Courtesy of the National Baseball Hall of Fame Library, Cooperstown, New York.)

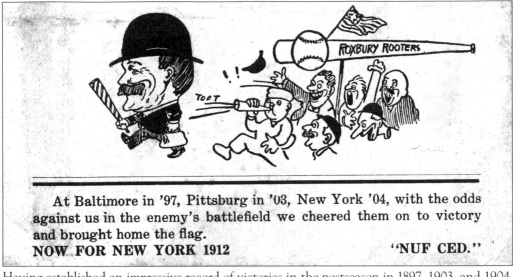

At Baltimore in '97, Pittsburg in '03, New York '04, with the odds against us in the enemy's battlefield we cheered them on to victory and brought home the flag.
NOW FOR NEW YORK 1912 "NUF CED."

Having established an impressive record of victories in the postseason in 1897, 1903, and 1904, the Rooters were ecstatic to return to their first World Series since 1903. This cartoon, produced by McGreevy before the 1912 World Series, documents their track record and proclaims their intentions to the baseball world.

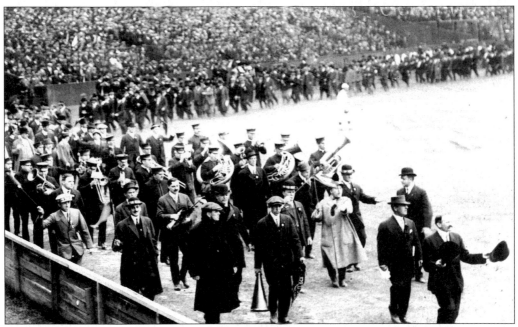

As the series moved to Fenway, the army of Royal Rooters (most of whom were also members of Elks Lodge No. 10), led by Nuf-Ced at the front of their procession, marched around the entire playing field waving their pennants, shouting in their megaphones, and rehearsing their renditions of "Tessie" before their new battle. Most of their banners and sashes carried the popular catch phrase from a 1912 song "Oh, You Red Sox." It was so popular that even socialite Isabella Stewart Gardner shocked her friends as she wore one of the sashes around her head to attend a Symphony Hall concert. Stewart was also a Fenway season-ticket holder. (Courtesy of the BPL Print Department.)

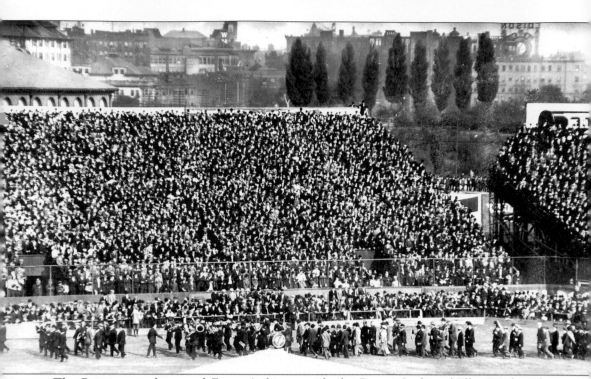

The Rooters march around Fenway's fringes with the Boston Lodge of Elks Band in front of the sold-out grandstands. The band was secured through the work of the members of the Winter League, who started planning for the World Series in August. This is the actual original photograph used for the World Series layout in the 1913 edition of *Reach's American League Base Ball Guide*. (Courtesy of the Garland Collection.)

MAYOR FITZGERALD LEADING CHEERING OF THE BOSTON ROOTERS AT THE POLO GROUNDS

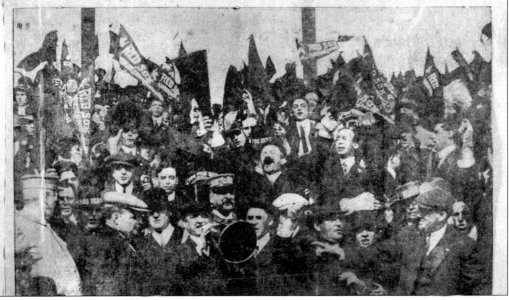

The Royal Rooters took their show back on the road to New York, and once again the party was led by Nuf-Ced and Boston mayor John "Honey-Fitz" Fitzgerald (with megaphone), whose connections helped secure game tickets. The newspaper headlines read "Rooters Arrive in Gotham, 'Tessie' Screams Her Defiance Along Broadway." The Rooters caused quite a stir parading down Broadway in automobiles singing "Tessie." This Boston newspaper item shows the frenzy of the Rooters when they finally got to the Polo Grounds. (Courtesy of the BPL Print Department.)

Nuf-Ced commissioned this Rooters' souvenir card featuring "Tessie" and a host of other songs he originally planned to utilize with close to 1,000 fellow rooters, but Honey-Fitz could only secure 300 tickets. Known as an expert amateur ballplayer, bowler, and handball champion, Nuf-Ced was also a songwriter, and he penned the 1912 tune "Knock Wood," dedicated to Boston ace pitcher Smoky Joe Wood.

ROOTER'S SOUVENIR
BOSTON - NEW YORK

OCTOBER 1912. "Nuf Ced" McGreevy

"EAT 'EM ALIVE!"—David Warfield

No. 1. **TESSIE**
CHORUS
Tessie, you make me feel so badly;
 Why don't you turn around.
Tessie, you know I love you madly;
 Babe, my heart weighs about a pound.
Don't blame me if I ever doubt you,
 You know I couldn't live without you;
Tessie You are my only, only, only.

"Kum-Kum! Be Alive! Get in the game!
 Fred Clark, (Pittsburg)

No. 2 Hobble Gobble, Hobble Gobble,
 Zizz! Boom! Bah!
 Boston, Boston, Rah! Rah! Rah!

No. 3. *Music—"In the good old Summer Time."*
In the good old summer time,
 Our Boston Base Ball Nine
Beat the teams—east and west
 Now they're first in line,
The New Yorks, they are after us,
 O me! O me! O my!
We'll do them as we did the rest
 In the good old summer time.

"Talk about Bill Carrigan's head,
 What about his block?"

"Booked for Hammersteins, two weeks"
 "Nuf Ced"

No. 4. Music—**TAMMANY**
Carrigan, Carrigan,
 Speaker, Lewis, Wood and Stahl,
Bradley, Engle, Pape and Hall;
 Wagner, Gardner, Hooper Too
Hit them, Hit them, Hit them, Hit them
 Do boys do!

"Money is vulgar, us for culture!"
 Boston Rooters, "Nuf Ced."

No. 5. Music—"Knock wood"
If you think you will win, all the tin,
 with a grin
Knock wood, watch Wood.
If they tell you too, say to you,
 you will do,
Knock wood, watch Wood.
If you guess you've got the Red Sox
 right,
Guess again, for you will have to fight,
The "Speed Boys" are the noise,
 they're the "joys,"
 Ship Ahoy!
Knock wood, watch Wood!

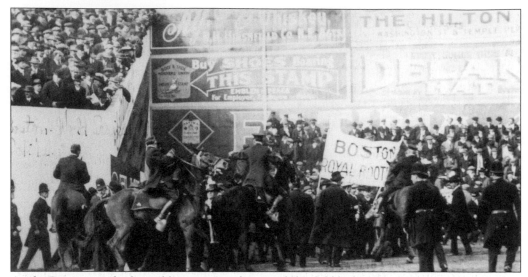

As the Rooters made their obligatory march around the field before game seven in Boston, they were dumbfounded when they realized that their seats had been sold. This image captures the chaos as police were sent in to diffuse the hot tempers of the Rooters who charged up Duffy's Cliff in left field. Management finally found a standing room spot for the Rooters, adding to the 32,000-plus crowd. The Sox still lost handily, 11-4, setting up a decisive game eight (game two was called due to darkness). The 2004 version of "Tessie" pays homage to the scuffle with the lyrics "McGreevy led the charge into the park, stormed the gates and put the game on hold." (Courtesy of the BPL Print Department.)

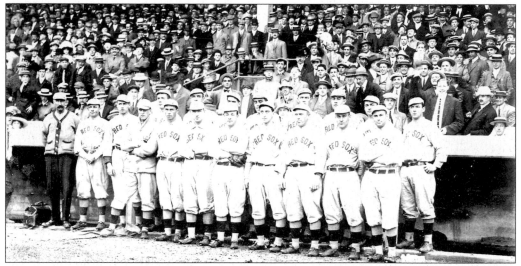

The Rooters blamed team management for the melee in game seven, not their beloved 1912 Sox (above). Sox president and Winter League member Jimmy McAleer was forced into an apology to the Rooters by Honey-Fitz, who also pleaded with management to avail more 25¢ seats in the park. Still, a bad taste was left in the mouths of the Rooters, who organized a boycott for the last game. Rooter Johnny Keenan stated, "We are through with the Red Sox, so far as the rooting goes, and we will not attend the final game tomorrow as a body." Only 17,034 fans showed up to see the Sox, who, despite the Rooters' absence, won their second World Series title. (Courtesy of the Garland Collection.)

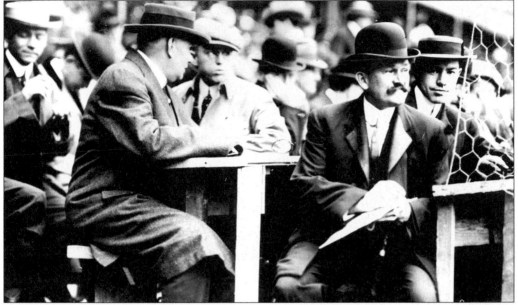

Nuf-Ced yearned for Boston's return to the World Series, as the Sox missed out on the fall classic from 1905 to 1911. Nuf-Ced (pictured here in the Shibe Park press box) had been rendered a mere spectator as he attended the World Series in Chicago in 1906 and Philadelphia in 1911. He returned to the game's grand stage in 1912.

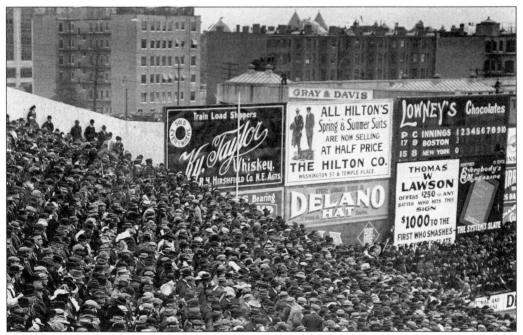

Nineteenth century "Krank" Thomas W. Lawson continued his career as an avid Sox supporter during the 1912 World Series. He commissioned this left field wall billboard in an act of ultimate self-promotion. On the wall and on a page in the ballpark program, he offered, "$250 to any batter who hits this sign, $1,000 to the first who smashes this systems slate." He never had the opportunity to make good on his offer.

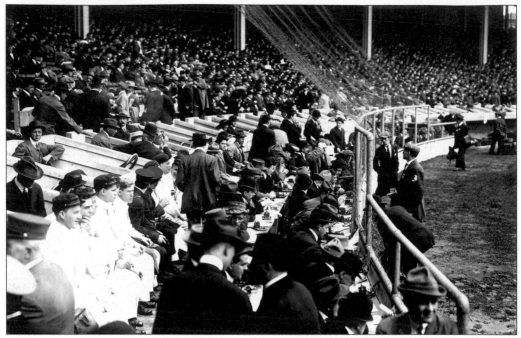

The Boston press and telegraph operators occupied these special boxes at the Polo Grounds and dispatched movements on the field back home to fans that were not able to join the Rooters on their raucous road trip. (Courtesy of the Garland Collection.)

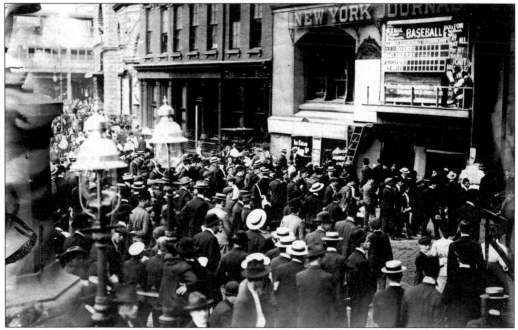

Fans would stand on street corners and watch large scoreboards report the World Series scores inning by inning. For a small fee, they could root along with Nuf-Ced and Honey-Fitz. This image shows a crowd assembled outside the *New York Journal* building during the 1912 World Series. (Courtesy of the Garland Collection.)

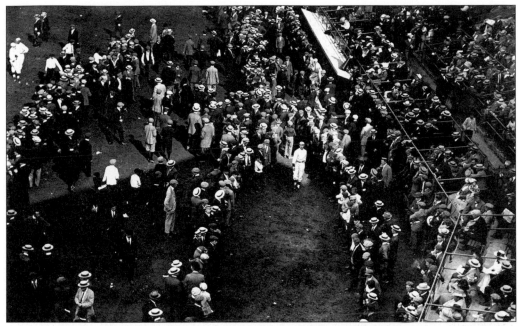

Fans who bought tickets for Fenway were afforded an intimate environment to take in a ballgame, as evidenced by this classic image of the Rooters hovering around Smoky Joe Wood before a 1912 regular season battle versus Walter Johnson. Fans had the opportunity to mill about the field during warm-ups before taking their seats. The box seats alongside the Sox dugout made for prime Fenway real estate. Some of the original season-ticket holders for these seats in 1912 have retained their rights to them and have passed the seats down from generation to generation.

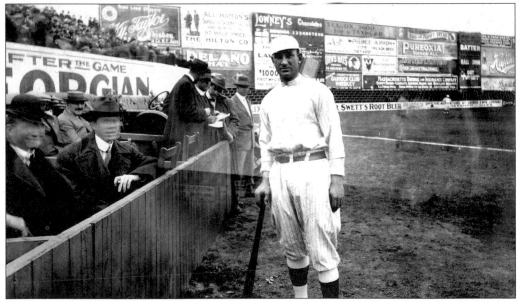

These Boston Royal Rooters in the front row at Fenway for the World Series had a different idea of what constituted "box seats." They were boxed in by wooden planks that separated them from the action, as they sat on the actual playing field. Here they share a moment before the game with soon-to-be-hero manager Jake Stahl. (Courtesy of the Garland Collection.)

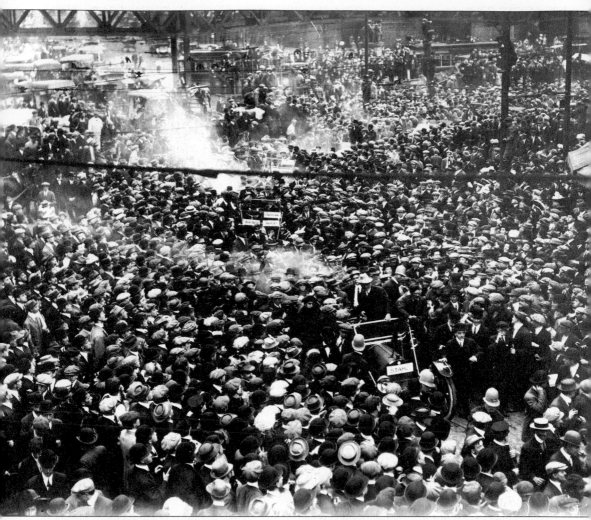

With the fiasco of game seven behind them, the Royal Rooters quickly jumped back on the bandwagon and celebrated wildly after the triumph over the Giants in game eight. This image captures the parade procession of the Red Sox in convertible automobiles featuring small signs with each player's name. The Royal Rooters led the parade of automobiles on foot from Park Square and passed by thousands of adoring Boston fans on their way to the grand reception at Faneuil Hall. It was the granddaddy of all Boston parades and set the standard for the modern spectacles arranged for the Super Bowl champion Patriots and the 2004 Red Sox. (Courtesy of the Garland Collection.)

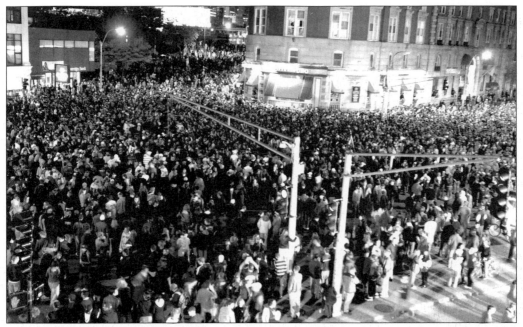

Fans in 2004 outside Kenmore Square after the championship game provide a mirror image of the Rooters close to a century ago. It would be impossible, however, to fathom what would happen if the modern-day Red Sox drove through thick Boston crowds in open convertibles without police barriers. (Courtesy of the *Boston Herald*.)

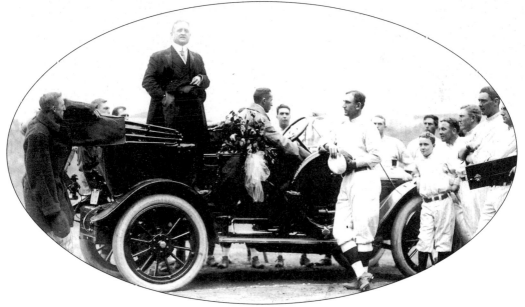

Part Royal Rooter and part politician, Honey-Fitz presided over the victory celebrations in Boston with great personal and civic pride. In his address to the team at the Faneuil Hall reception to the team on October 17, 1912, he proclaimed, "But to you, Manager Stahl, speaking for the people of Boston, I extend the congratulations of the city. I hope all of your team will long remember the pride that Boston takes and has shown today in their success." He presents Manager Jake Stahl with a new automobile in this photograph by Louis Van Oeyen. (Courtesy of the Garland Collection.)

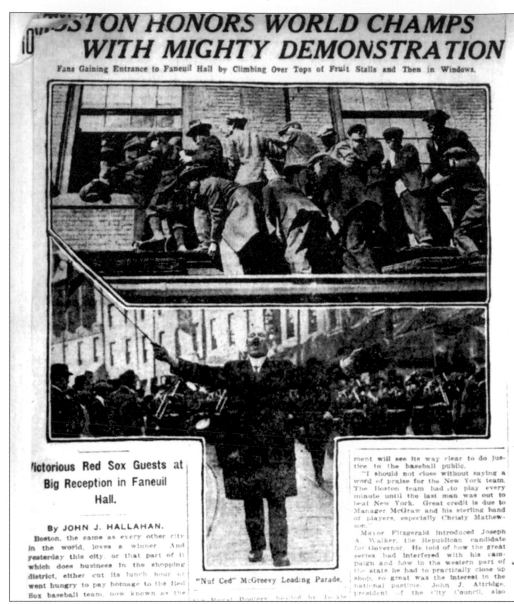

BOSTON HONORS WORLD CHAMPS
WITH MIGHTY DEMONSTRATION

Fans Gaining Entrance to Faneuil Hall by Climbing Over Tops of Fruit Stalls and Then in Windows.

Victorious Red Sox Guests at Big Reception in Faneuil Hall.

By JOHN J. HALLAHAN.

Boston, the same as every other city in the world, loves a winner. And yesterday this city, or that part of it which does business in the shopping district, either cut its lunch hour or went hungry to pay homage to the Red Sox baseball team, now known as the

"Nuf Ced" McGreevy Leading Parade.

ment will see its way clear to do justice to the baseball public.

"I should not close without saying a word of praise for the New York team. The Boston team had ,to play every minute until the last man was out to beat New York. Great credit is due to Manager McGraw and his sterling band of players, especially Christy Mathewson."

Mayor Fitzgerald introduced Joseph A. Walker, the Republican candidate for Governor. He told of how the great series had interfered with his campaign and how in the western part of the state he had to practically close up shop, so great was the interest in the national pastime. John J. Attridge, president of the City Council, also

In what was described by Honey-Fitz as "the greatest [demonstration] I have ever witnessed in Faneuil Hall," the champions were honored with a grand reception and parade led by none other than Nuf-Ced. McGreevy is shown in this newspaper report, waving his hands like a symphony conductor as he strikes up the rooters' band and summons the cheers of his fellow Bostonians. Fans (pictured above) were so anxious to be a part of the celebration they climbed over fruit stands to scale the walls of Faneuil Hall and sneak into the reception through open windows. (Courtesy of the BPL Print Department.)

In appreciation for their organization of rooters before the World Series and support during the World Series, the Winter League members were honored with a hot-stove testimonial dinner tendered by the Red Sox organization at the behest of president Jimmy McAleer. This image shows the cover of the program and menu for the event held at the Boston Tavern on January 30, 1913.

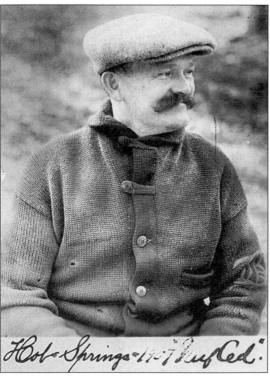

The Winter League members included Royal Rooters, sportswriters, ex-players, and baseball executives who made the annual spring training pilgrimage with the Sox to either Hot Springs, Arkansas, or Los Angeles. Nuf-Ced appears on this autographed real-photo postcard taken at Hot Springs around 1907. (Courtesy of the BPL Print Department.)

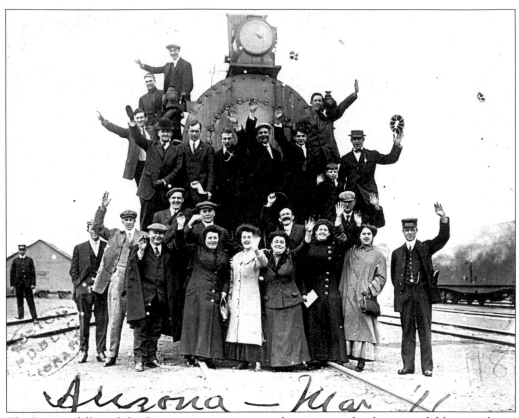

The Rooters followed the Sox to spring training each season in what became a lifelong tradition for some. In 1911, they decided to make their camp out west in Los Angeles and chartered a special train soon to be known as the Red Sox Special. This image shows the group of Rooters and their wives standing in front of the train as it made a stop in Arizona. Nuf-Ced waves his hat as the only mustached Rooter. The engraving below was featured on custom-made Red Sox stationary from 1915 commemorating the Red Sox Special train that made spring jaunts from coast to coast. (Above, courtesy of the BPL Print Department.)

While in Hot Springs, the Winter League, the Rooters, the Boston press, and the Red Sox were treated like kings by the locals, who hosted banquets and smokers in their honor. In March 1910, Nuf-Ced was unable to join the tight-knit group who signed this banquet menu from the Arlington Grill and inscribed, "To Nuf-Ced from the Bunch." They addressed the menu to McGreevy at 3rd Base and sent it off to him with a postage stamp.

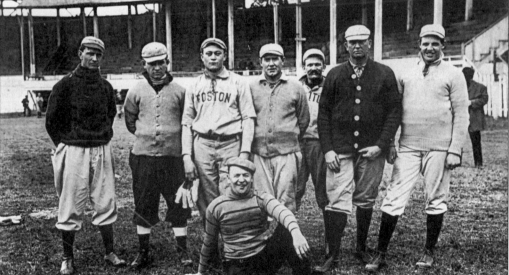

Nuf-Ced suits up with Cy Young and other major-leaguers in this spring training photograph. In the spring of 1907, while Nuf-Ced was practicing with the Sox, a minor-league owner approached Sox owner John I. Taylor to purchase McGreevy for his own team. Sensing the comic possibilities, Taylor played along with the ruse and accepted a $200 check for the sale of Nuf-Ced. At a later date, the Sox signed McGreevy to a tongue-in-cheek contract so he was "protected" as a good luck charm of sorts. (Courtesy of the BPL Print Department.)

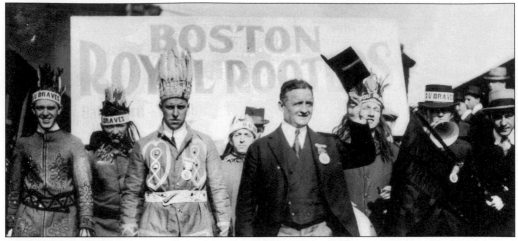

While the Rooters were primarily Red Sox fans, they still showed strong support for the National League's Braves (formerly the Beaneaters and Doves). Although the Braves were a losing franchise, the 1914 club, under Manager George Stallings and captain Johnny Evers, pulled off an incredible comeback to capture the National League pennant. When they faced Connie Mack's A's at Braves Field, the Rooters came out of the woodwork to root for the franchise that first stole their hearts. As Boston's mayor, Honey-Fitz led the rooters in support of the underdog club that took the baseball world by storm. (Courtesy of the BPL Print Department.)

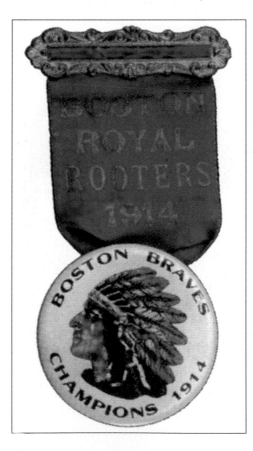

The Rooters wore badges like this one as they jumped on the bandwagon and cheered the "Miracle Braves" to a storybook world championship over Mack's powerful A's.

Five

THE BAMBINO IN BEANTOWN

In 1914, new Boston owner Joseph Lannin purchased pitchers George Herman "Babe" Ruth and Ernie Shore for what was then a whopping $30,000 from the financially strapped Jack Dunn and the Baltimore International League club. It was one of the Red Sox's most significant acquisitions ever. Ruth's prowess as a skilled and powerful pitcher propelled the Sox to new heights as they ruled the American League once more. The young Ruth was brash and unrefined, and while he rubbed some teammates the wrong way, he was a favorite of the Royal Rooters, and a frequent customer at Boston watering holes, 3rd Base included.

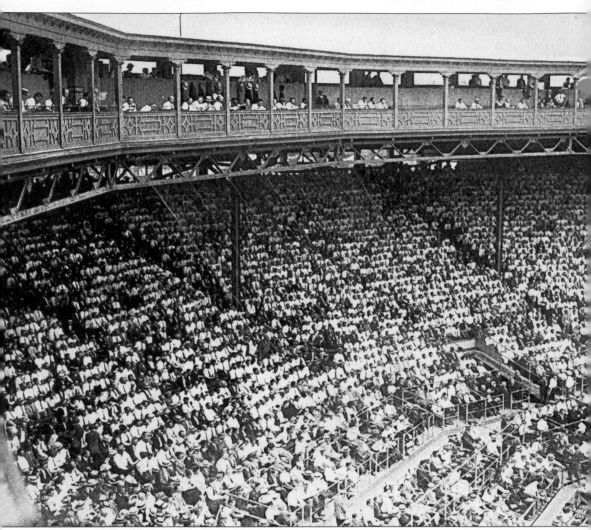

By the end of Ruth's first full season in 1915, the Sox were primed to return to the fall classic once again. This image shows the Fenway capacity crowd of rooters on September 18, 1915. The upper level sections appear as somewhat primitive luxury boxes reserved for the press. Note the finely crafted pattern of the figural façade. (Courtesy of the BPL Print Department.)

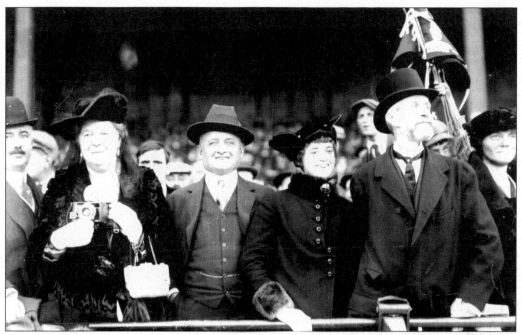

Mayor Fitzgerald hosted Great Britain's Lord and Lady Aberdeen at the 1915 World Series, which was played at Braves Field instead of Fenway to accommodate additional fans. The Royal Rooters' usual game time antics were not a factor as the Sox steamrolled past the Philadelphia Phillies four games to one. (Courtesy of the BPL Print Department.)

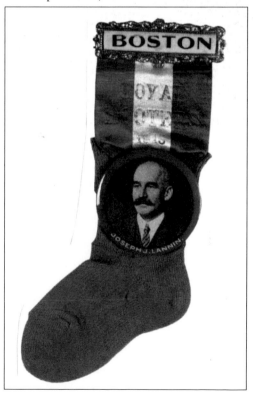

Owner Joseph Lannin, beloved by the Rooters whom he considered friends, was honored to have his visage grace the group's 1915 badge made specifically for the World Series versus Philadelphia.

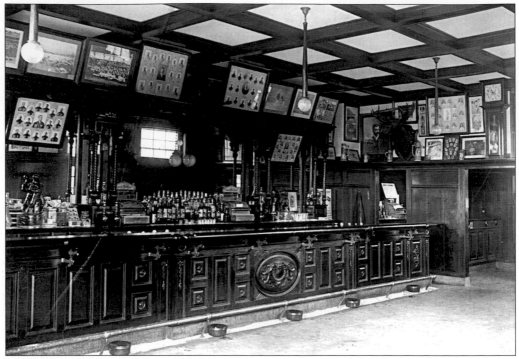

McGreevy's 3rd Base saloon made its final move sometime after the 1915 World Series to 1153 Tremont Street. The interior mirrored the Columbus Avenue location, known to locals as "the Baseball Place." The tavern's clock incorporated a pendulum bat and baseball weight, as well as the words "Boston and Nuf-Ced" replacing the numbers of the clock face. After the last World Series victory in 1918, Prohibition and the sale of Babe Ruth signaled that times were changing. In 1920, the *Boston Traveler* reported, "The room . . . where the strains of 'Tessie,' the old Boston Baseball war song, made the rafters tremble; that room is now strangely silent—almost deathlike." (Courtesy of the BPL Print Department.)

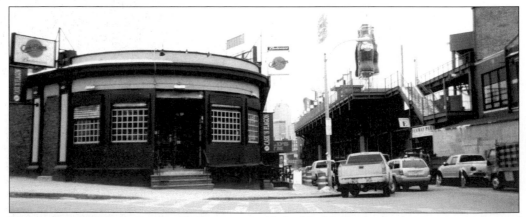

The tradition of the Boston baseball tavern established by McGreevy lives on in the shadows of Fenway's Green Monster at the now legendary Cask 'n Flagon.

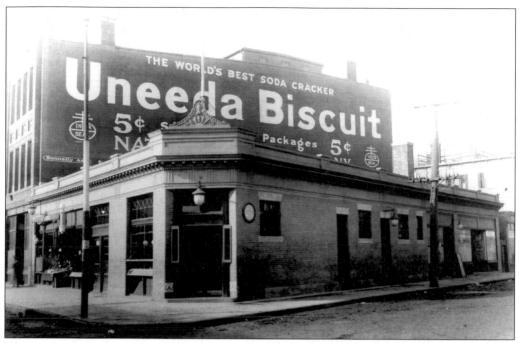

The image above shows the exterior of McGreevy's tavern just before the 1920s after his move to Tremont Street, which was closer to Fenway Park. As Prohibition hit Boston in 1920, the bar closed its doors for good and, in 1923, became a branch of the Roxbury Crossing branch of the Boston Public Library. The photograph below shows Jimmy Rooney's Baseball Tavern on Brookline Avenue as it looks today. Owned by the Rooney family since 1963, its exterior looks eerily similar to Nuf-Ced's Tremont digs. While the interior is not decorated as profusely as the 3rd Base of 1903, the tavern has a framed picture of Roger Clemens in a Sox uniform hanging upside down. (Above, courtesy of the BPL Print Department.)

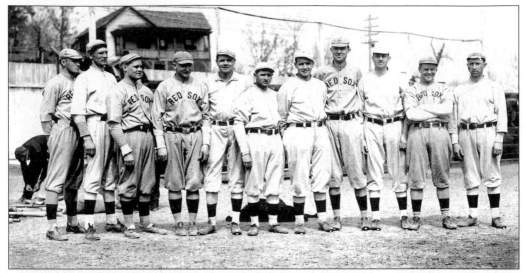

The Babe poses here (fifth from the left) in a rare image with the Sox pitching staff in Hot Springs, Arkansas, during spring training in 1915. Ruth traveled with the Winter League contingent of the Royal Rooters and, as a mere rookie (and newlywed), had already exhibited a proclivity for fast times. Smoky Joe Wood appears second to Ruth's left. Wood led the 1915 American League with the lowest ERA but, by the season's end, was finished as a pitcher due to injury. Wood and Ruth were not used in the 1915 World Series, however, Ruth's presence on the staff in 1916 would more than compensate for the loss of Wood's former mastery.

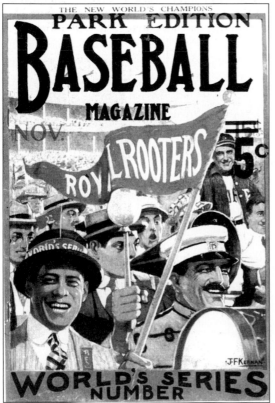

At the apex of their fame, the Rooters were featured on the cover of Jacob Morse's 1915 World Series edition of his popular *Baseball Magazine*. (Courtesy of the BPL Print Department.)

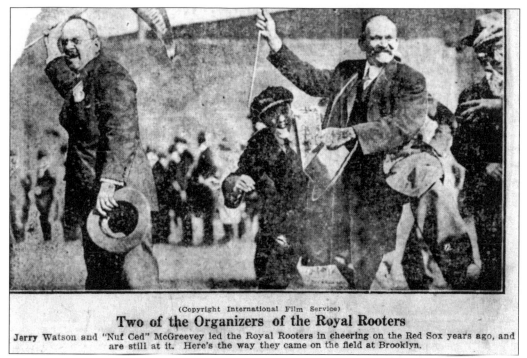

Two of the Organizers of the Royal Rooters

Jerry Watson and "Nuf Ced" McGreevey led the Royal Rooters in cheering on the Red Sox years ago, and are still at it. Here's the way they came on the field at Brooklyn.

The Sox returned to the World Series in 1916 to battle Wilbert Robinson's Brooklyn Dodgers. Behind Babe Ruth's pitching prowess, McGreevy and Jerry Watson waved their Rooters pennants proudly, having made the road trip to Brooklyn's Ebbets Field. This image from Nuf-Ced's scrapbook shows the organizers of the Royal Rooters as they entered the field in Brooklyn. (Courtesy of the BPL Print Department.)

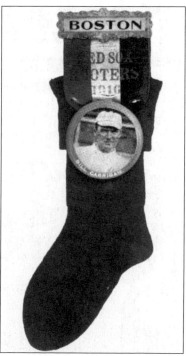

The Rooters paid tribute to manager Bill Carrigan on their 1916 badge, which also featured a rather large red cloth in the shape of a sock.

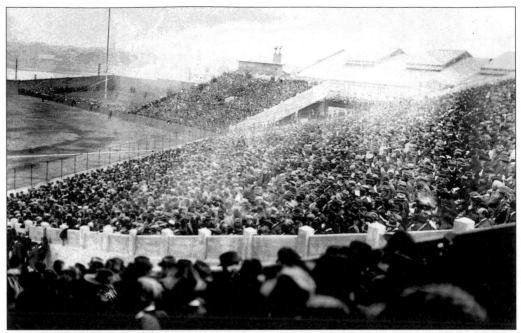

For purely financial reasons, the 1916 World Series games in Boston were played at Braves Field because of its superior capacity to Fenway. (Courtesy of the National Baseball Hall of Fame Library, Cooperstown, New York.)

Boston American League Base Ball Club
Fenway Park

Admit *M. T. McGreevy*

During Season of 1916

This Pass Book is NOT TRANSFERABLE. It will be forfeited and taken up by Gate Keeper if presented by any other than person named above, and holder's name will be stricken from Pass List and further courtesies will not be extended. Coupons must be detached only by Gate Keeper.

Sign your name on back inside Cover.

No. 013

President

Pictured is Nuf-Ced McGreevy's 1916 full-season ticket book, which only has one stub left for a game on October 3rd. (Courtesy of the BPL Print Department.)

After his World Series triumph, Babe Ruth and other Sox teammates went on a tour of New England to greet their adoring fans. In this photograph, the Babe meets New Hampshire schoolgirls sporting a dapper raccoon coat. (Courtesy of the Plymouth Historical Society.)

Fans came to the aid of a good friend when they attended Murnane Day at Fenway in September 1917. A Winter League member and dear friend of the Royal Rooters, *Boston Globe* writer Tim Murnane died tragically in the lobby of a Boston theater, a victim of a heart attack. Ex-Boston owner John I. Taylor got together with Rooters like Honey-Fitz and Jack Dooley and formed a committee to organize an all-star game for the benefit of his widow and children.

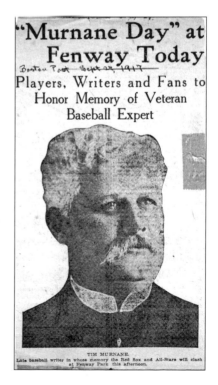

"Murnane Day" at Fenway Today

Players, Writers and Fans to Honor Memory of Veteran Baseball Expert

TIM MURNANE.
Late baseball writer in whose memory the Red Sox and All-Stars will clash at Fenway Park this afternoon.

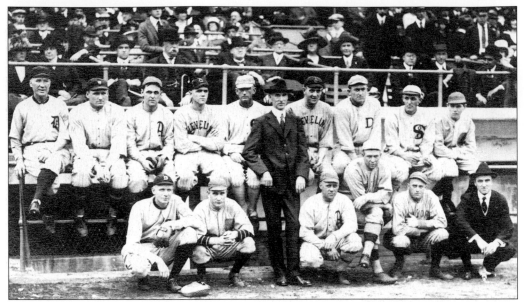

Native New Englander Connie Mack (center in suit), whose brother Dennis was a vocal Royal Rooter, returned to Fenway for the benefit of his old friend to manage the team of American League All-Stars. The Boston fans showed great support as they flocked to Fenway to aid the Murnane family's cause. They watched a classic game as the ex-champion Red Sox beat an all-star team that featured the likes of Shoeless Joe Jackson, Ty Cobb, Tris Speaker, Buck Weaver, and Walter Johnson.

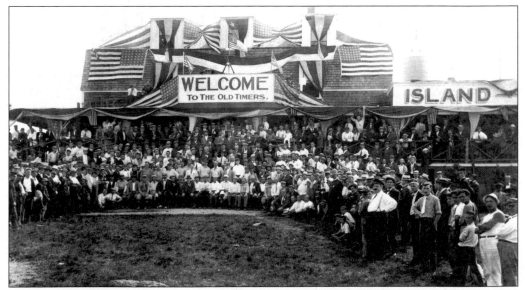

The Boston fans were perhaps one of the first groups in baseball history to honor their favorites of yesteryear. At Charles Irwin's hotel on Peddock's Island in Boston Harbor, they hosted one of the earliest Old-Timers Days on record. In attendance were aging legends like Candy Cummings, Dickie Pearce, and Jack Manning. Nuf-Ced is in the thick of it along with his fellow Rooters and scribe Tim Murnane. (Courtesy of the National Baseball Hall of Fame Library, Cooperstown, New York.)

This group of dapper Boston rooters from the 1918 season are lined up outside the ballpark. By the time the World Series returned to Beantown, the first games would ultimately take place in Chicago, where a group of the Rooters traveled out west in full force led by Johnny Keenan. (Courtesy of the BPL Print Department.)

A 1918 ticket stub like this one got a Rooter into Comiskey Park (used because of its superior capacity to Wrigley Field) for game two of the World Series. Rooters back in Boston followed the games in theaters and on public scoreboards. By the time the World Series returned to Boston for game four, the Rooters serenaded the Cubs players and fans at the Hotel Brunswick with the now famous strains of "Tessie."

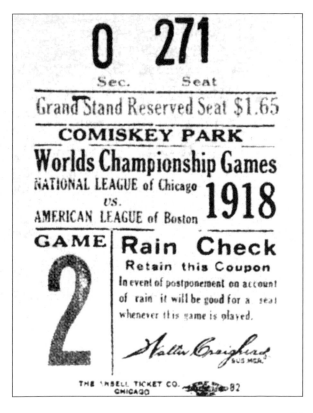

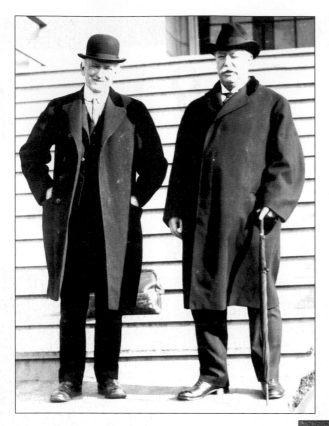

Rooter and Massachusetts governor Samuel McCall, pictured here to the left of President Taft, was given the last-out ball of the 1918 World Series by Sox first baseman Stuffy McInnis. Upon its presentation, he stated his intention to place the ball in the statehouse, where it could be displayed and enjoyed by his fellow citizens. The ball's whereabouts today are unknown. (Courtesy of the BPL Print Department.)

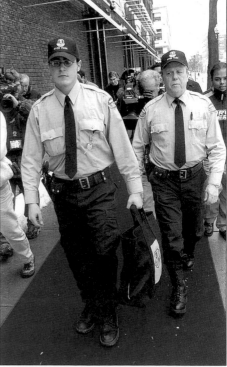

In contrast, the controversy over the last-out ball of 2004 culminated with the armed escort into Fenway Park pictured to the right. Larry Lucchino echoed McCall's sentiments in his desire to give all of New England an opportunity to view the ball. (Courtesy of the *Boston Herald*.)

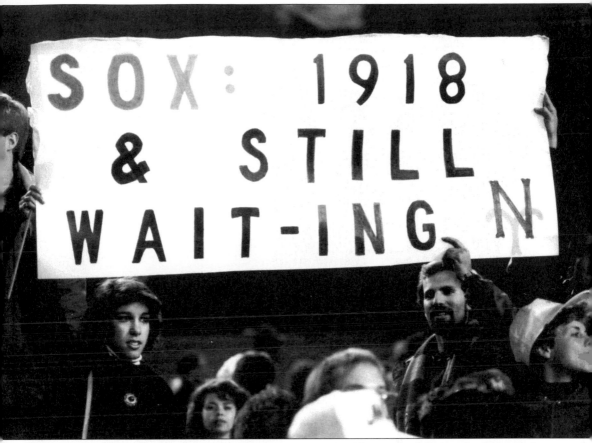

As each year passed, the numbers 1-9-1-8 took on greater significance in defining the failures of the Boston franchise. New York fans, especially Yankees diehards, took to using the year as an antagonistic chant, reminding Sox players and fans of their long draught. New York Mets fans utilize these tactics in this image taken at the forgettable 1986 World Series. (Courtesy of Tom Heitz, the National Baseball Hall of Fame Library, Cooperstown, New York.)

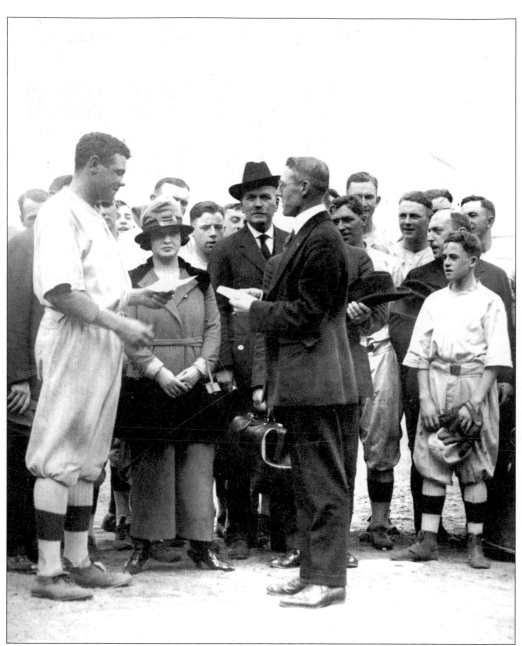

As 1919 progressed with the Sox out of pennant contention, the Babe was still hitting home runs at a record pace. On September 20, he was honored with Babe Ruth Day at Fenway. It was the last time fans would see him in a Sox uniform. After the season, the Rooters and the Knights of Columbus honored him at dinners and exhibition games; however, by January 6, 1920, he was dealt to New York by owner Harry Frazee for a record price. Royal Rooter Charles Lavis voiced his displeasure with the deal, as did his fellow Rooter Johnny Keenan, who claimed that Ruth was irreplaceable. Conversely, many fans supported the sale, as did Winter League member Hugh Duffy, who was quoted as saying, "No matter how great a star is, he hurts a team if he does not fit with his fellow players." (Courtesy of the National Baseball Hall of Fame Library, Cooperstown, New York.)

Fans were exposed to the news of Ruth's sale on the front pages of the Boston papers. When Nuf-Ced got the news, he was decidedly dejected to lose his friend and was prompted to make the foreboding prediction: "Every real Boston fan will regret his departing."

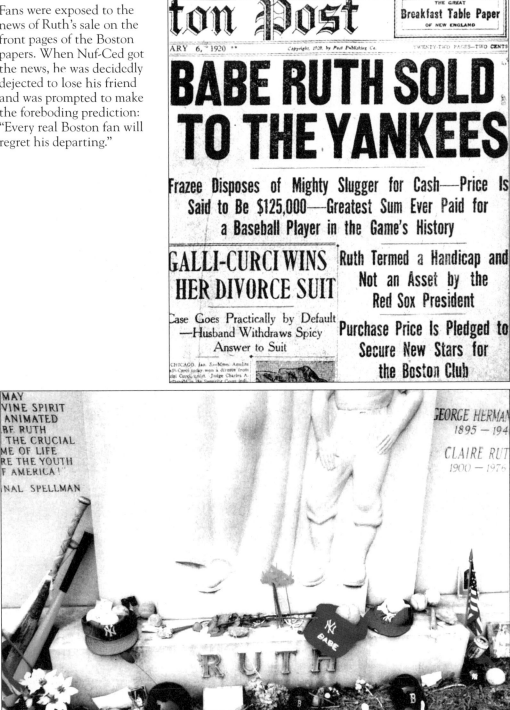

ton Post

THE GREAT
Breakfast Table Paper
OF NEW ENGLAND

ARY 6, 1920 ** Copyright, 1920, by Post Publishing Co. TWENTY-TWO PAGES—TWO CENTS

BABE RUTH SOLD TO THE YANKEES

Frazee Disposes of Mighty Slugger for Cash—Price Is Said to Be $125,000—Greatest Sum Ever Paid for a Baseball Player in the Game's History

GALLI-CURCI WINS HER DIVORCE SUIT

Case Goes Practically by Default —Husband Withdraws Spicy Answer to Suit

CHICAGO, Jan. 5—Mme. Amelita Galli-Curci today won a divorce from her Curci, artist. Judge Charles A. McDonald, in the Superior Court jurl.

Ruth Termed a Handicap and Not an Asset by the Red Sox President

Purchase Price Is Pledged to Secure New Stars for the Boston Club

MAY
VINE SPIRIT
ANIMATED
BE RUTH
THE CRUCIAL
ME OF LIFE
RE THE YOUTH
F AMERICA!"

NAL SPELLMAN

GEORGE HERMAN
1895 — 194

CLAIRE RUT
1900 — 1976

RUTH

Close to 86 years after the sale, New York and Boston fans made pilgrimages to the grave of the Bambino, hoping to extend or extinguish the curse that plagued Red Sox Nation. They left hats, gloves, bats, balls, beer, and even hotdogs for the "Sultan of Swat." (Courtesy of the National Baseball Hall of Fame Library, Cooperstown, New York.)

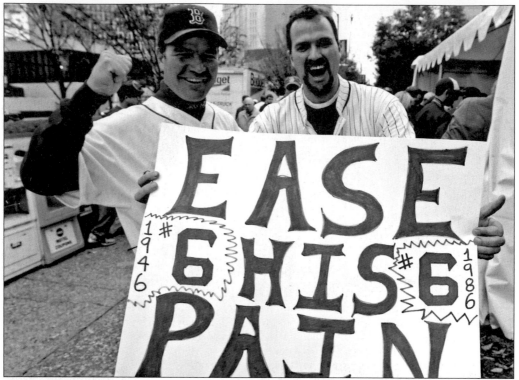

These 2004 Royal Rooters traveled to St. Louis searching for their own field of dreams. After 86 years, fans became slaves to superstition, making pleas to higher authorities on signs like this one. The pain accrued over the 86 years since the victory in 1918 was a burden most Sox fans found intolerable. (Courtesy of the *Boston Herald*.)

On August 31, 2004, 16-year-old Sox fan Lee Gavin was hit in the head with a Manny Ramirez foul ball, losing two teeth. What made the event memorable was the fact that Gavin actually lived in Babe Ruth's old house in Sudbury, Massachusetts. This photograph shows the house in the Bambino's day. For the rest of the season, Lee was known as "the Curse Kid" and by October, was believed by many to be "the Kid Who Broke the Curse." (Courtesy of Linda Ruth Tosetti.)

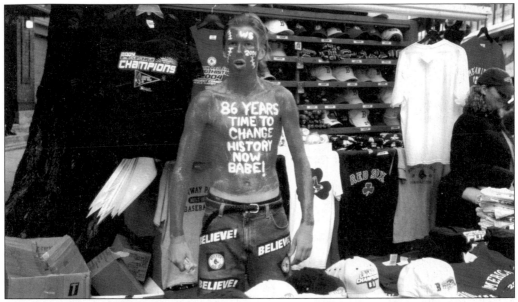

This fan summed up the sentiments of all of Red Sox Nation as the 2004 World Series returned to Boston. While Nuf-Ced McGreevy could never have imagined the bare chest as a ballpark billboard, he would surely have respected the sign painter's ingenuity and dedication to the cause. (Courtesy of Brita Meng Outzen.)

The Babe's granddaughter Linda Ruth Tosseti, a Connecticut resident, is a member of the BLOHARDS—the Benevolent Loyal Order of the Honorable Ancient Red Sox Die-Hard Sufferers—most of whom live in Connecticut or work in New York. After the 2004 World Series, Sox principal owner John Henry expressed his thanks for her support and told her how he never believed in the curse. Henry further revealed the franchise's desire to continue their connection to the Babe through Linda (pictured above). To the left, the Babe holds his own bambino, Linda's mom. (Courtesy of Linda Ruth Tosetti.)

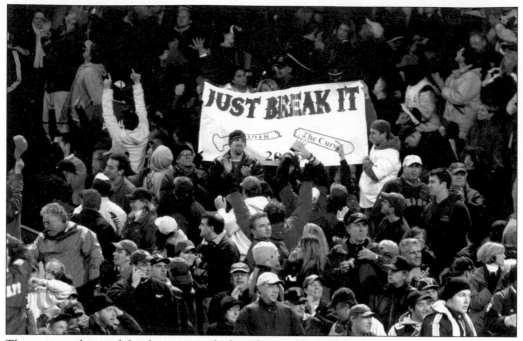

The curse took on a life of its own with the release of Dan Shaughnessy's books and a bevy of curse-related souvenirs sold throughout New England and New York. The Boston fans' desire to break it rose to an all-time high in 2004. (Courtesy of the *Boston Herald*.)

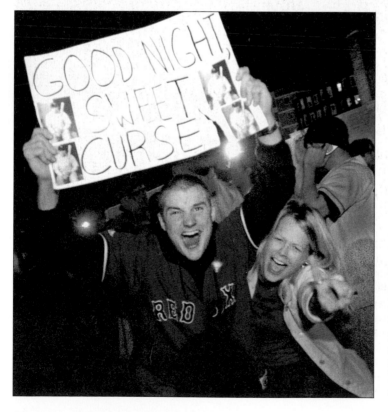

After the game four sweep of St. Louis in 2004, fans jammed Kenmore Square and streets all over New England as they finally felt the ultimate jubilation that was once a common occurrence for the old Roxbury Rooters. (Courtesy of the *Boston Herald*.)

Six

HONEY-FITZ:
KENNEDY CURSE REVERSED

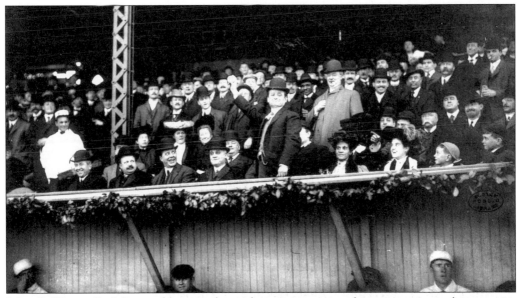

John F. "Honey-Fitz" Fitzgerald enjoyed presiding over opening day ceremonies in his capacity as either mayor or congressman. Whether it was at the Huntington Avenue Grounds or Fenway Park, it was a safe bet that Honey-Fitz would be tossing out the ceremonial first pitch. He reveled in each opportunity to captivate the large ballpark crowds that would break out in song, serenading him with "Tessie" or his campaign song "Sweet Adeline." His daughter Rose looks on in this image (second to his right) as her father poses at the Huntington Avenue Grounds around 1906. Both father and daughter played key roles in shaping a political dynasty that would dominate the landscape of American politics. However, few have recognized the parallels between the political triumphs and tragedies of the Fitzgerald and Kennedy clans and the victories and misfortunes of the Boston Red Sox franchise. (Courtesy of the BPL Print Department.)

Honey-Fitz used his position as a Royal Rooter to keep himself in the public eye after he lost the mayoral race in 1901. In 1904, he made an unsuccessful attempt to buy the world champion Boston franchise from Henry Killilea for $140,000. His rivals helped kill the deal by interceding with American League president Ban Johnson, as they painted him as a political operator too strong to harness and a liability for the league.

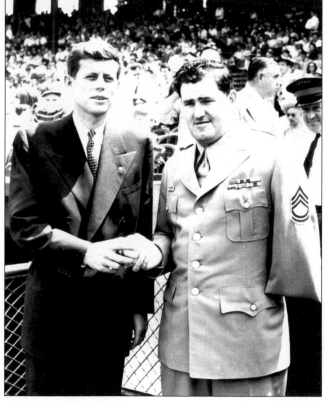

Honey-Fitz would gain his greatest fame as the grandfather of John F. Kennedy. His grandson would continue the family tradition of using the club for campaigning purposes as he posed at Fenway in 1946 with this wounded World War II veteran who was slated to toss out the first pitch. (Courtesy of the BPL Print Department.)

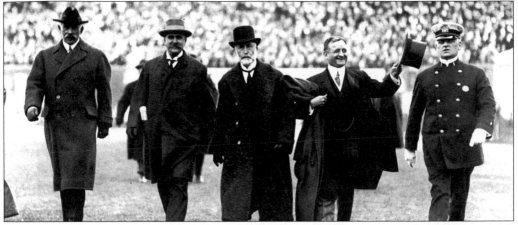

Honey-Fitz won the Boston mayoral election of 1905, but his first term was plagued by scandal. Following suit, after winning pennants in 1903 and 1904, the soon-to-be-named Red Sox experienced seven straight seasons as also-rans, while the resilient Honey-Fitz, seen here waving his hat, won a second term in 1909. The Sox pennant of 1912 was a return to glory for the Rooters and Honey-Fitz, who, along with New York mayor William Jay Gaynor (to his left), paraded in the newly christened Fenway Park during the 1912 World Series. (Courtesy of the JFK Library.)

Saloon keeper, Irish ward boss, fellow Royal Rooter, and Honey-Fitz's political rival and ally, P. J. Kennedy was linked with the Fitzgeralds through his son Joseph. While Joseph was dating his daughter Rose, Honey-Fitz unknowingly presented his future son-in-law with the 1908 Mayor's Trophy for the best high school batsman. Joseph batted .667 and appears seated in the center of this photograph with his Boston Latin School teammates. Historian Doris Kearns Goodwin has noted how P. J. shared "his love for the game with his son, playing ball in the yard with him for hours each day and taking Joe with him to all the games of the Boston Red Sox." (Courtesy of the JFK Library.)

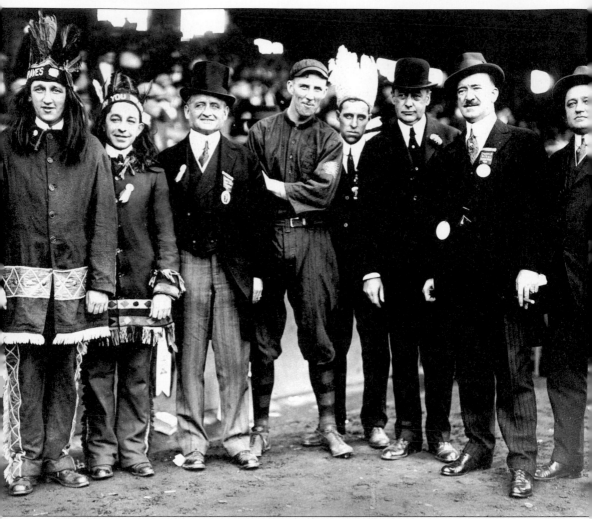

After their nuptials on October 7, 1914, Joe and Rose Kennedy embarked on their three-week honeymoon to White Sulphur Springs, West Virginia. Curiously, little has ever been written of their first stop on the way down south to accompany Honey-Fitz and the Royal Rooters to the first two games of the 1914 World Series in Philadelphia. The newlywed fans watched Boston's "Miracle Braves" defeat Connie Mack's Athletics as Nuf-Ced printed up a new song for the Rooters: "Oh, the World Series banner, how proudly it waves, 'oer the land of the bean, and the home of the Braves." Although Honey-Fitz was cool to the idea of Rose marrying Joe, his baseball background as a player and Rooter must have helped in his acceptance of the soon-to-be stock manipulator and political guru. Honey-Fitz is pictured here with World Series hero Hank Gowdy and fellow Rooters in Native American headdresses.

As Honey-Fitz played a smaller role in Boston politics, he continued his connection with the Royal Rooters through the glory years of 1915 to 1918. Joe Kennedy (pictured here as an amateur player) became president of his father's Columbia Trust Bank and, following in the footsteps of his father-in-law, attempted to purchase the Red Sox in 1916 as part of a group of investors but was outdone by the infamous Harry Frazee. Rumors resurfaced in 1920 that he was trying to buy the club, this time from Frazee after the sale of Babe Ruth. (Courtesy of the JFK Library.)

During game five of the 1918 World Series, players staged a 45-minute strike, protesting the sum of their World Series bonuses. Honey-Fitz calmed the fans at Fenway until play resumed. The Sox went on to win the World Series, and Honey-Fitz won the November election for Massachusetts House seat in the 10th district. But in 1919, he was indicted for voter fraud. As Honey-Fitz fell, Babe Ruth was sold, and Honey-Fitz's fellow Rooter Sport Sullivan conspired at the Hotel Buckminster (pictured above) to fix the 1919 World Series. Beginning in 1918, Boston's baseball misfortunes gave rise to speculation of a curse. Whether it was what author Edward Klein has coined "the Kennedy Curse" or simply coincidence, the fall of Honey-Fitz was followed by triumphs and tragedies of the Kennedy family that were shadowed by Red Sox heartbreaks.

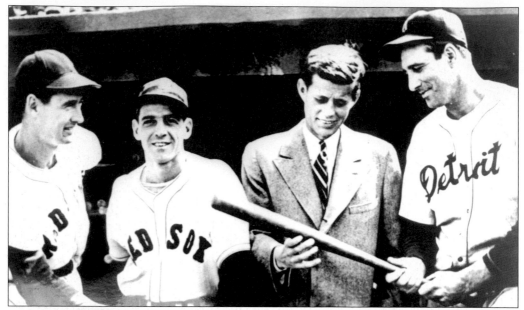

Honey-Fitz campaigned with John F. Kennedy as he made his 1946 bid for a seat in the U.S. Congress. Father Joseph was behind the scenes, with his win-at-all-costs mentality and a desire to limit Honey-Fitz's campaign role. Carrying on a family tradition, JFK capitalized on his Red Sox connection with voters. In an ethnically strategic photo op, he is pictured here with Ted Williams, Eddie Pellegrini, and Hank Greenberg. With the power of Joseph's checkbook and family connections, JFK was on his way to a groundbreaking victory. Meanwhile, the hometown Red Sox were poised for victory as well, headed for their first American League pennant in years. (Courtesy of the JFK Library.)

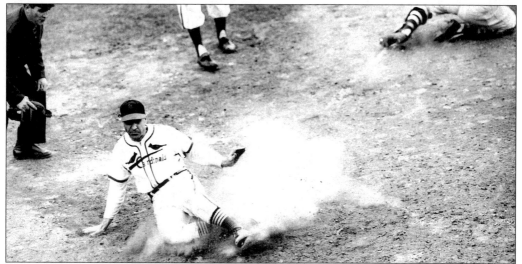

As the Kennedy political machine mobilized with cash and a finely tuned campaign organization, the American League champion Red Sox were on a crash course to face the St. Louis Cardinals in the 1946 World Series. With Honey-Fitz's assistance, JFK was also on his way to a November victory while, conversely, the Red Sox endured the first in a long line of heartbreaks when Cardinal Enos Slaughter slid into home and stole the World Series from the Fenway faithful. (Courtesy of the National Baseball Hall of Fame Library, Cooperstown, New York.)

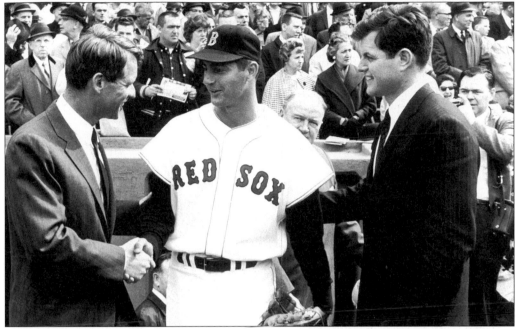

In the wake of the family's greatest tragedy, the assassination of JFK, the Kennedy clan continued their support of the Red Sox, as brothers Bobby and Teddy went forward with their own political careers. In this image, the brothers flank Carl "Yaz" Yastrzemski on the field at Fenway, in awe of the team's new star. Yaz gave the Sen. Ted Kennedy his 1967 MVP trophy and 1967 Gold Glove award, which are today on display at Kennedy's Boston office. (Courtesy of the JFK Library.)

Relocated and living in New York, widow Jacqueline Kennedy takes in opening day at Yankee Stadium on April 14, 1967, with JFK Jr. (holding a Cracker Jack box). The Yankees lost the contest to the Red Sox 3-0. (Courtesy of the National Baseball Hall of Fame, Cooperstown, New York.)

Honey-Fitz was adored by his grandchildren. One of his favorite pastimes was taking the kids to Fenway on weekends to watch the dismal Sox teams of the 1920s and 1930s. Coincidentally curse-related, historian Doris Kearns Goodwin states that when Joseph Jr. and Jack (JFK) were 11 and 9, their father went to Hollywood and was negotiating movie deals with none other than Babe Ruth. JFK and his older brother, Joseph Jr., flank their grandfather in this photograph taken sometime in the early 1940s. JFK carried on the Royal Rooter tradition in his presidency, always staying for the entire nine innings at opening days and even creating an "Undersecretary of Baseball" position for his colleague Dave Powers. (Courtesy of Tom Fitzgerald.)

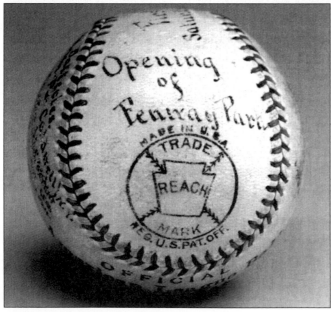

Honey-Fitz threw out this very ball for the ceremonial christening of Fenway Park on opening day in 1912. Umpire Tommy Connolly pocketed the ball and inscribed the event in full detail. In June 2005, his family offered the ball at Sotheby's in New York, where it sold along with the document that sold Babe Ruth to the Yankees in 1920.

After JFK's assassination, the Red Sox honored his memory with an opening day benefit in 1964 for the JFK Library. Brothers Bobby and Ted joined "Stan the Man" Musial (third from the left) on the field at Fenway during the pregame ceremony. All gate receipts from the game went to a fund to establish the JFK Library. (Courtesy of the JFK Library.)

During the "Impossible Dream" season of 1967, Ted and Bobby took their father and Sen. Hubert Humphrey to one of the last games of the pennant race against the Minnesota Twins. They witnessed the clinching of the pennant, and as Sen. Ted Kennedy recalls, "Jose Santiago, the pitcher that day, gave me the game-winning ball." Unlike Honey-Fitz and Joseph Sr., none of the Kennedy kids had ever experienced a world championship victory in person. All of New England was primed for the World Series against St. Louis only to meet another crushing game seven defeat at Fenway by Bob Gibson. (Courtesy of the JFK Library.)

Honey-Fitz's grandson Tom recalls when his grandfather invited him to the Braves' pennant-clinching game of 1948, at the age of 14. They entered Braves Field free of charge and sat in box seats, but in the thick of it, they headed down to the clubhouse. Honey-Fitz assumed that the Braves would win, and he wanted to congratulate them in the locker room. Honey-Fitz fielded questions from Jim Britt, the voice of the Braves. He waxed poetic about the old days only to be interrupted by Britt, who was looking for a more contemporary view. The heyday of the Rooters had clearly passed, but Honey-Fitz had some moxie left, snapping, "Damnit, I'm not through yet!" as he yanked the microphone back and continued. Here Tom stands in Fenway with his own grandson, fifth-generation Royal Rooter, Ronan. (Courtesy of Tom Fitzgerald.)

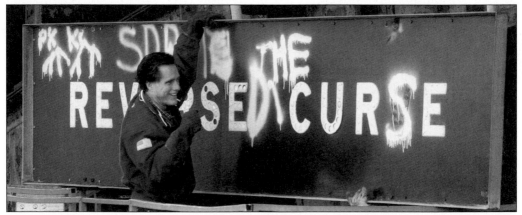

In the tradition of Honey-Fitz, Gov. Mit Romney stands before the once infamous "Reverse the Curse" highway sign after the 2004 Sox victory. Sox rooter Maria Shriver (who once dated Sox owner Larry Lucchino) may have helped to break the curse, as she broke her foot when she jumped off a couch after David Ortiz hit a three-run homer in game one of the World Series. From the Senate floor, in the presence of President Bush, Senator Kennedy brought the saga full circle stating, "My grandfather was Mayor of Boston when Fenway Park first opened. . . I'm sure he's smiling down on this year's team as well, and I'm delighted that my own grandchildren could savor this year's victory." (Courtesy of the *Boston Herald*.)

Seven

RED SOX NATION'S FIRST FAMILY: THE DOOLEYS

John S. Dooley and his daughter Elizabeth presided over what has today become the behemoth of Red Sox Nation. Known as "John S." or "Jack" to his cronies and as "my little Irishman from Boston" to American League founder Ban Johnson, he was reported to have attended every opening day in Boston from 1882 to 1971. He witnessed the first game of night baseball in Hull, Massachusetts, helped secure the land for the original Huntington Avenue Grounds in 1900, sang "Tessie" with his fellow Rooters at the first World Series in 1903, founded the Winter League fan group in 1904, and almost always accompanied the Sox to spring training every March. His daughter Elizabeth "Lib" Dooley followed in his footsteps, becoming the "Queen of Fenway Park," famous for attending close to 4,000—almost consecutive—Sox home games from 1944 through 2000. She became the first female president of the BoSox Club, was a close friend and confidant of Ted Williams, and was named by ESPN as the No. 3 sports fan of all time. Renowned as great Rooters, they (pictured above at Fenway) preferred not to be known as fans, but rather as friends of the Red Sox.

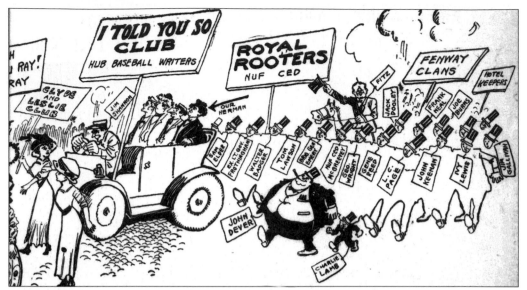

This 1912 Sid Green cartoon documents Jack Dooley's prominence in the Royal Rooter clan, along with fellow cranks Nuf-Ced, Honey-Fitz, Thomas Lawson, and John Dever, as well as hall of famer and Boston legend George Wright. Born on Christmas Day, 1873, Dooley attended his first games with his older brothers in the late 1870s at the Clarendon Street Park to watch Wright and other stars like Tim Murnane and John Morrill. (Courtesy of the BPL Print Department.)

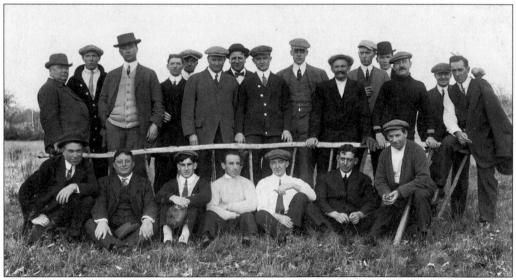

Dooley worked for his older brother William and also for J. M. Prendergast and Company Cotton and Yarn Brokers at 87 Milk Street. His leisure time was spent playing amateur and semiprofessional ball as a pitcher and traveling as a rabid Roxbury Rooter, who was a close friend of hall of famers like Hugh Duffy and Tommy McCarthy (known as the "heavenly twins"). Dooley appears in this 1912 photograph (bottom right, holding a baseball bat) with Duffy and McCarthy (bottom far left), Nuf-Ced (top, third from right), and Red Sox president Jimmy McAleer (top, third from left). This get-together took place at O'Brien's Farm in Holliston after the Red Sox World Series victory over the New York Giants. Sox pitcher Buck O'Brien is seated, third from left.

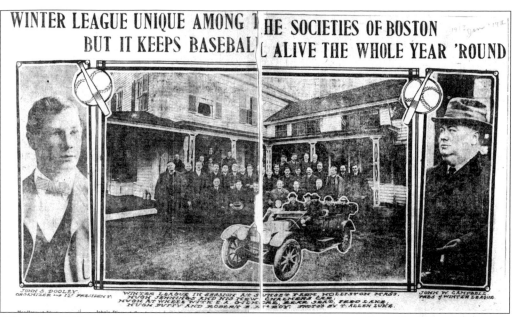

After the 1903 season, Jack Dooley founded the Winter League, Boston's original hot-stove organization. With their headquarters at the Boston Tavern and Holliston's Sunset Farm, Dooley, Nuf-Ced, Tim Murnane, Duffy, John W. Campbell, and a host of others pioneered the off-season discourse that has evolved into today's Red Sox Nation presence on the Internet and sports talk radio. Pictured above in a newspaper article pasted into Nuf-Ced's scrapbook are Dooley and his Winter League partners in front of Sunset Farm in 1907. (Courtesy of the BPL Print Department.)

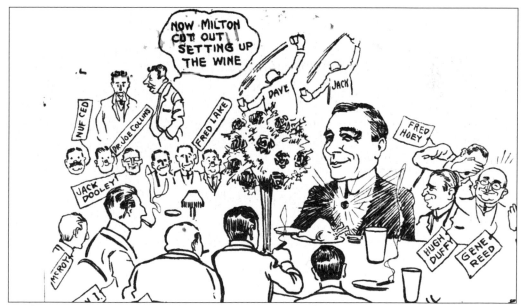

Dooley and company extended their love for the game beyond Boston's borders and regularly held testimonials for other prominent baseball stars like Detroit's Hughie Jennings, who was honored in Holliston in the winter of 1907. This Sid Greene cartoon recreates the scene at Woodbury's as Jack Dooley and Nuf-Ced kept the hot stove burning in the winter months. (Courtesy of the BPL Print Department.)

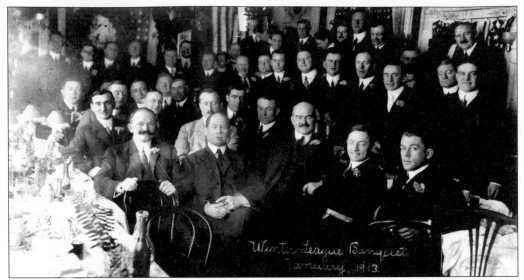

With a 1912 world championship in their back pockets, the Rooters involved in the Winter League tradition were thrown a benefit smoker by their heroes at the Boston Tavern on January 30, 1913. Sox batboy and mascot Jerry McCarthy kicked off the event with a well-received rendition of "Tessie." Later in the evening, Jack Dooley was surprised by Sox president Jimmy McAleer when he honored him with a diamond ring. Dooley appears in this rare photograph from that evening (front, seated with cigar in hand) with Nuf-Ced seated to his left. Hugh Duffy appears to the right over Dooley's shoulder. (Courtesy of the BPL Print Department.)

Dooley's friendship with Duffy continued well into the pair's golden years. This photograph shows the duo departing to Sarasota for spring training in 1952 (Duffy's 62nd annual trip). Dooley was a spring training regular. Today John Dooley III attends Sox spring training games, as he continues the family tradition with a seasonal residence in Fort Myers.

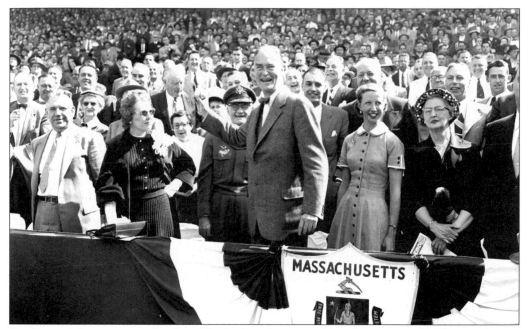

Dooley took his youngest daughter Elizabeth to Braves Field and Fenway Park whenever he got the chance. It was common for hall of famers like Duffy and Rabbit Maranville to drop by their Roxbury home or their summer place in Nantasket. Elizabeth spent a lot of time in the press box, as her father made the rounds with other Rooters, and she took to baseball more than any of her other siblings. Around the time she took a job as a Boston schoolteacher, she decided to get her own season tickets at Fenway. She is shown here in her front row seat next to Gov. Christian A. Herter as he throws out a ceremonial first pitch.

Both father and daughter followed the Sox religiously, and their durability as friends of their struggling Red Sox was recognized by fellow fans and the franchise itself. In 1963, the cartoon portrait to the left appeared in the Sunday *Boston Herald* when Dooley was honored as a member of the One Half Century Club of Boston Fans. In 1969, he was presented with a silver cup from Red Sox manager Johnny Pesky in recognition for his loyalty to the club.

Ted Williams was one of Jack Dooley's favorite ballplayers. He poses with Williams in this c. 1950 snapshot from spring training. His daughter Lib became a close friend and confidant of the man she called Theodore, considering herself the sister he never had. To Lib, Williams's surly disposition was misunderstood.

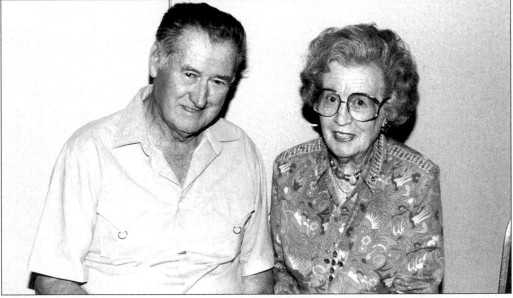

Lib Dooley is shown here with Williams at his Hitter's Museum in Florida. She was his VIP guest for years, sometimes being picked up in a limo at the airport by the likes of Pres. George H. W. Bush and his wife, Barbara. When Williams was honored at the 1999 All-Star Game at Fenway, he made sure to pass Lib in section 36 to wink and blow a kiss. Though many biographies have been written about Williams, none has covered the true depth of their relationship. When Lib's niece Ann Tobin called Ted to inform him of her aunt's passing in 2000, Ted told her how he once proposed to the woman he called Boston's greatest fan. But since Ted had been previously divorced, Lib's mother and father, both devout Irish Catholics, would not consent to their union.

Lib's nephew Billy Martin was a chip off the Dooley block, and as a young boy, Lib took care of him like no one else could. She took him to games, got him in uniform, and arranged quality time visits with Ted like the one captured in this July 1951 snapshot. Like her father, Lib enjoyed grooming the next generations of Dooley rooters.

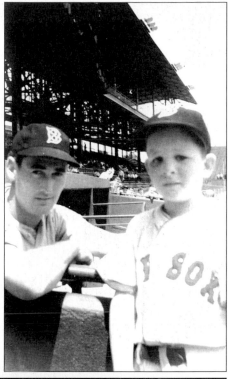

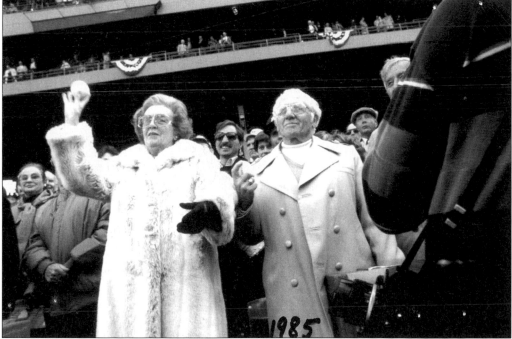

As the years marched on and Jack passed away at the age of 95 in 1971, Lib assumed the mantle of number one fan in the Hub and was afforded the honor of throwing out the ceremonial first pitch on opening day in 1985. This image captures her right-handed toss to open up the new baseball season.

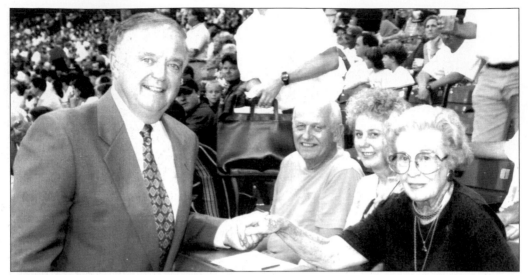

Lib Dooley's status as Fenway's grand dame afforded her visits from a host of baseball notables, who would pay their respects at her front row seats next to the Sox dugout. She would bake cookies and put them on the ledge in front of her seat for the likes of Carl Yastrzemski, Jim Rice, Nomar Garciaparra, Mo Vaughn, and even the batboys. Aside from the game itself, Lib enjoyed the friendships she made with prominent figures like Sox owner John Harrington (above), and the unsung heroes who worked at the park as vendors, ticket takers, ushers, and maintenance men.

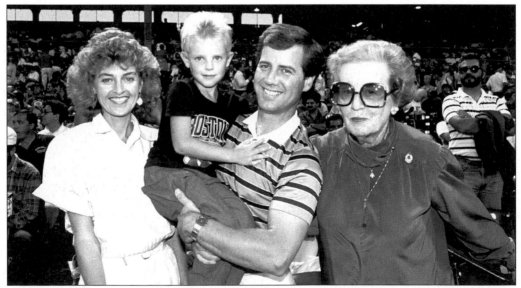

Lib is pictured here with her nephew Owen Boyd, his wife, Chris, and their son Michael. With Jack and Lib Dooley's influence, Owen had aspirations of becoming a ballplayer. When he was in a big slump as a Little Leaguer, Ted Williams intervened and tutored him with a month of personal batting instruction. Crediting Williams, Owen went on to a successful amateur career and excelled to the ranks of professional ball in the Red Sox farm system. When Lib passed away in 2000, her last will and testament revealed her wishes to pass on her cherished Fenway seats to Owen and his brother Brian. Although the Red Sox had no legal obligation, they honored her request as a tribute to her loyalty to the franchise.

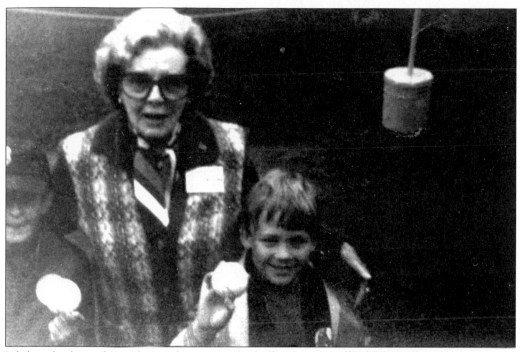

Lib loved taking those close to her out to the ballpark, especially the kids. She's shown in this 1982 photograph with grandnephew David Leary holding up baseballs on the fringes of Fenway's infield. Although its reported Lib attended over 4,000 consecutive games at Fenway, in actuality, she missed a few due to her attending David's graduation and a few family weddings here and there. (Courtesy of Mary Leary.)

The *Globe*'s Dan Shaughnessy wrote Lib's obituary, calling her "the greatest Red Sox fan of them all." He described the moment of silence in her honor before the first game after her death and interviewed her grandnephew David Leary, who sat in her seat at row 36-A (pictured here). Leary called the game against the Yankees, "the first game of the next era of Red Sox baseball" and secured a game ball from the 22-1 Red Sox loss to place in Lib's casket at her wake in Milton the next day. (Courtesy of Mary Leary.)

A new generation of Red Sox fans was inspired by Jack and Lib Dooley. The BoSox Club was established due to the influence of Jack's Winter League group, and Lib became the first woman to serve on the club's board of directors. She is pictured here in her last years at a BoSox Club banquet with her good friend Johnny Pesky. Another pal was Dom DiMaggio, who recalls how excited Lib was when she presented the team with their American League championship rings in 1946. As a testament to her relationship with Red Sox legends, Pesky and DiMaggio attended her funeral services in 2000. (Courtesy of Mary Leary.)

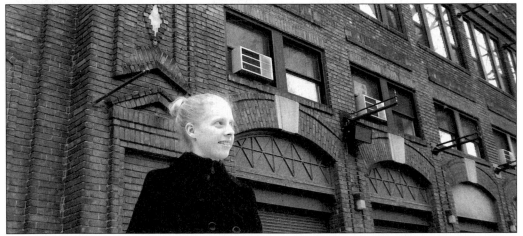

The spirit of Lib Dooley lives on in her grandniece Cheryl Boyd, who has exhibited Lib's undying faith in the Red Sox. During the American League Championship Series of 2003, she posted anti-Yankee signs all over the walls of her school. In the 2004 postseason, she distributed replica "Tessie" song cards and wore her grandfather's gold and diamond ring for good luck, the ring given to him by the Red Sox after their World Series victory in 1912. On October 2, it was lost; but it was miraculously found days later by her father on a local street under a pile of leaves. When the Sox were down 3-0 to the Yankees, Cheryl never wavered, writing a poem to friends foreshadowing a Sox comeback. She turned the poem in at school the next morning to her teacher, Mrs. Miracle.

Eight

THE FENWAY FAITHFUL

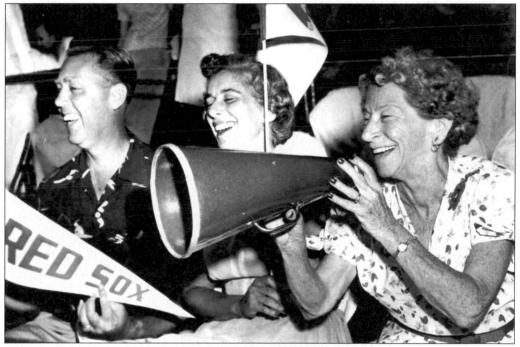

Placed on a lineup card of rooters in between first ladies Lucy Swift and Lib Dooley was Howling Lolly Hopkins, pictured above with her signature megaphone. A die-hard Sox fan whose memories dated back as far as 1912, she was a fixture at Fenway from the 1930s through the 1950s, with an aisle seat right behind the Red Sox dugout. A widow of a Rhode Island train conductor, she made the trip free of charge from Providence to Boston for every Sox home game for decades. The *Sporting News* called her the "Hub's No. 1 Howler" and enlisted a psychiatrist to examine the nature of female fans, including Hopkins and Brooklyn's Hilda Chester. The conclusion was that male fans were "oddballs and screwballs" seeking an outlet, while female fans like Hopkins were "devoted to a cause, to a ball club, to baseball." (Courtesy of the National Baseball Hall of Fame Library, Cooperstown, New York.)

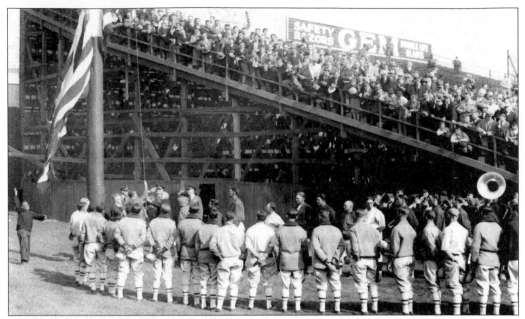

Having not raised a championship pennant since 1918, rooters at opening day in 1924 settled for the raising of old glory. When the Sox brought ex-champion manager Bill Carrigan back into the fold as manager in 1927, the surviving Royal Rooters were briefly coaxed out of retirement. Nuf-Ced organized a spring training delegation with Uncle Bill Cahill and Cupid Burns. The retired champion rooter Michael Regan even came out of the woodwork. But after an optimistic start to the season, the Sox reverted back to their losing ways. (Courtesy of the National Baseball Hall of Fame Library, Cooperstown, New York.)

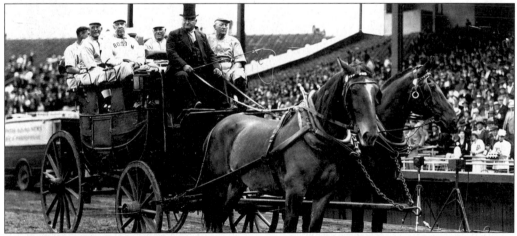

"Tessie" returned on September 8, 1930, for the *Boston Post*'s Old-Timers Day benefit in honor of ex-champion catcher Lou Criger. Bandleader Jimmy Coughlin revived the tune much to the chagrin of scores of fans, including Nuf-Ced, who taunted Honus Wagner (in attendance) for old time's sake. Stars like Fred Tenney, Candy LaChance, and Cy Young were driven into Braves Field on Pat Daly's Tally Ho. A nostalgic *Boston Post* writer called the event, "the greatest day in Boston's baseball history." Nuf-Ced contributed $25 to the cause for Criger's health and wrote the *Post* suggesting they give "tickets among some poor kids or disabled veterans that they may enjoy the same thrills that I am going to get."

In 1938, Nuf-Ced showed off King Kelly's 1887 *Boston Globe* Medal for Base Stealing. A fellow Rooter acquired the medal in a New York City pawnshop in 1907 and delivered it to Nuf-Ced at 3rd Base. McGreevy did not make it to many games around 1938. He suggested that modern players did not think the same way. He also suggested speeding up the game by eliminating the center fielder. After his death, Nuf-Ced's granddaughter Alice personally returned the medal to the *Globe* offices. The *Globe*, in turn, donated the medal to the National Baseball Hall of Fame. (Courtesy of the BPL Print Department.)

In 1923, Nuf-Ced presented the Boston Public Library with many of the photographs from 3rd Base. It is now the M. T. McGreevy Baseball Collection, which has provided scores of baseball historians with rare images and data. To honor baseball's mythical centennial, the library decorated a window at Filene's department store with Nuf-Ced's photographs. His granddaughter Alice recalls the pride he felt when he first walked past the window in 1939, shown above. Four years later, on February 2, 1943, Nuf-Ced died at the age of 77. (Courtesy of the BPL Print Department.)

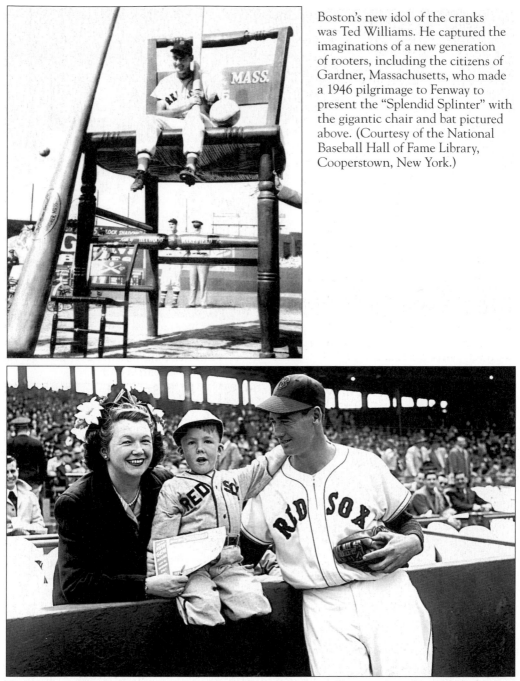

Boston's new idol of the cranks was Ted Williams. He captured the imaginations of a new generation of rooters, including the citizens of Gardner, Massachusetts, who made a 1946 pilgrimage to Fenway to present the "Splendid Splinter" with the gigantic chair and bat pictured above. (Courtesy of the National Baseball Hall of Fame Library, Cooperstown, New York.)

No player since Babe Ruth was as popular as Williams, pictured here with an adoring mother and son around 1946. Nuf-Ced's widow, while on her deathbed in 1955, asked her priest if Williams had yet signed his new contract, which was in dispute with the Sox, and informed him she would be praying for his signing. Soon after, the *Boston American*'s Alan Frazer reported the answer to her prayers as he wrote, "Mrs. McGreevy had just time enough to get to heaven, where I may surmise she rejoined 'Nuf-Ced,' the most loyal fan the Red Sox ever had, when Ted announced he was coming back." (Courtesy of the BPL Print Department.)

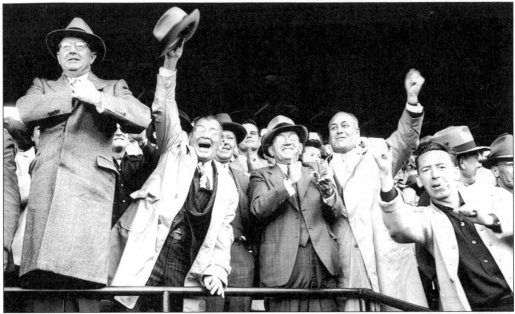

With Nuf-Ced gone, a new breed of rooters haunted the confines of Fenway Park, cheering the exploits of new stars like Williams, Dom DiMaggio, Johnny Pesky, and Bobby Doerr. The die-hard core of old-time rooters, who were of primarily Irish descent, were joined by thousands of others with ethnic backgrounds. (Courtesy of the BPL Print Department.)

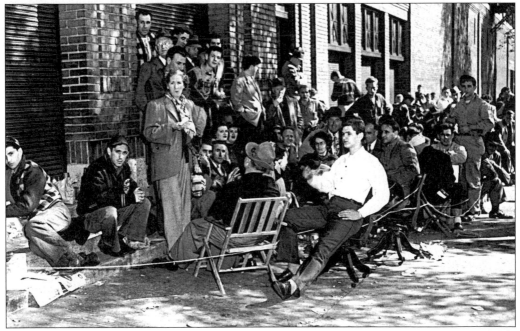

The original Royal Rooters passed away one by one as the newly christened "Fenway Faithful" endured the pain of each season, longing for the return of the world championship. In this 1949 photograph, fans listen to the last game of the season versus the Yankees and optimistically set up camp outside Fenway to be first in line for World Series tickets upon a Sox victory that would never come to pass. (Courtesy of the BPL Print Department.)

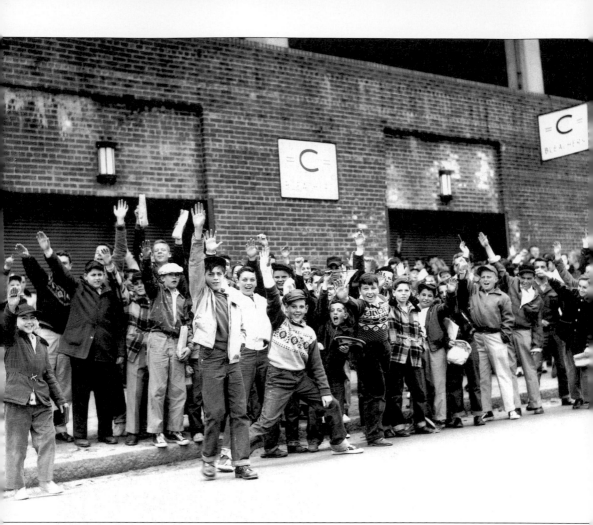

Even in tough times, fans still could not get enough of their beloved Red Sox. Fenway's youngest fans are seen here crowding the bleacher entrance on opening day in 1956. (Courtesy of the BPL Print Department.)

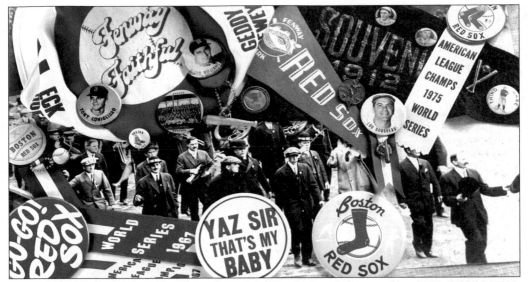

The concept of Red Sox souvenirs was pioneered by the Royal Rooters from 1903 through 1918. (They wave some of their wares here in 1912.) Nuf-Ced's initial pins and song cards gave rise to souvenir hawkers who peddled pennants, pins, and caps. The D'Angelo brothers, twins Henry and Arthur, came from Italy to Boston in 1939, and by the mid-1940s, began selling Red Sox pennants and Ted Williams-related souvenirs to fans on a whole new level. The enterprising D'Angelos made a name for themselves with their "badge boards" and pennants, ultimately forming the fully licensed Twins Enterprises. This image shows a montage of Boston souvenirs sold over the last century.

This image shows souvenir king Arthur D'Angelo giving to the Jimmy Fund as a successful Fenway-based businessman. Today his company employs over 100 workers and wholesales baseball souvenirs to various entities. While they did not invent the idea of baseball fan merchandising, the D'Angelos took the original market created by the Royal Rooters and propelled it to the new heights of today's Red Sox Nation. (Courtesy of Twins Enterprises.)

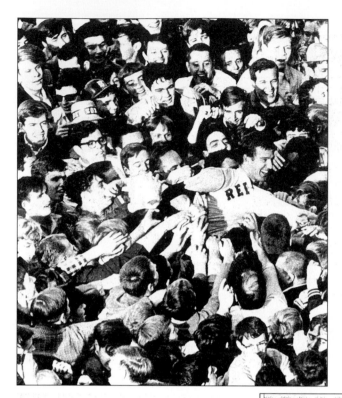

Jim Lonborg was swarmed by the Boston fans much like Fred Tenney was back in 1897 by the original Royal Rooters. Lonborg had just won the final game of the 1967 season, which became known to Bostonians as the "Impossible Dream." (Courtesy of the *Boston Herald*.)

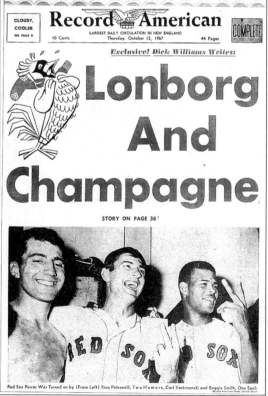

This cover of the *Boston Record American* echoes Sox fans' sentiments as they prepare themselves for the winner-take-all game seven versus the Cardinals in the 1967 World Series.

1967 WORLD SERIES
AMERICAN LEAGUE vs. NATIONAL LEAGUE
FENWAY PARK

BOX SEAT
$12.00

DO NOT DETACH THIS COUPON FROM RAIN CHECK

GAME 7

1967 WORLD SERIES
BOSTON RED SOX
FENWAY PARK
AMERICAN LEAGUE vs. NATIONAL LEAGUE
ADMIT ONE
SUBJECT TO THE CONDITIONS SET FORTH ON BACK HEREOF.
PLAYED UNDER THE SUPERVISION OF
WILLIAM D. ECKERT, Commissioner of Baseball

GAME 7

BOX SEAT $12.00

RGHT

BOX SEAT 36 A 4

BOX SEAT $12.00

RAIN CHECK
BOSTON RED SOX. AGENT

This ticket stub, which belonged to legendary fan Lib Dooley, represents the closest she ever came to witnessing a world title for her beloved Sox. As she sat in her front row seat in box 36, she experienced the same agony as millions of other Boston fans, snake bit once again. Recovering from the loss during the season of 1968, her father Jack was asked by a reporter, "What if the Red Sox don't win the pennant, Mr. Dooley?" The 95-year-old Royal Rooter responded, "Then, like everybody else, I'll have to wait until next year."

Through the years, Sox fans had the pleasure of listening to legendary broadcaster Curt Gowdy. In this 1965 photograph, Gowdy (standing) is shown broadcasting from the center-field bleachers for the first time in Fenway history. A fan favorite, Gowdy's knowledge included an awareness of the Royal Rooters. In fact, Nuf-Ced's daughter wrote to him in 1962 and expressed what a fan she was of his work. After the 2004 victory, Gowdy hosted a NESN special in which he chronicled the history of the Royal Rooters and "Tessie" for modern-day Sox fans. (Courtesy of the BPL Print Department.)

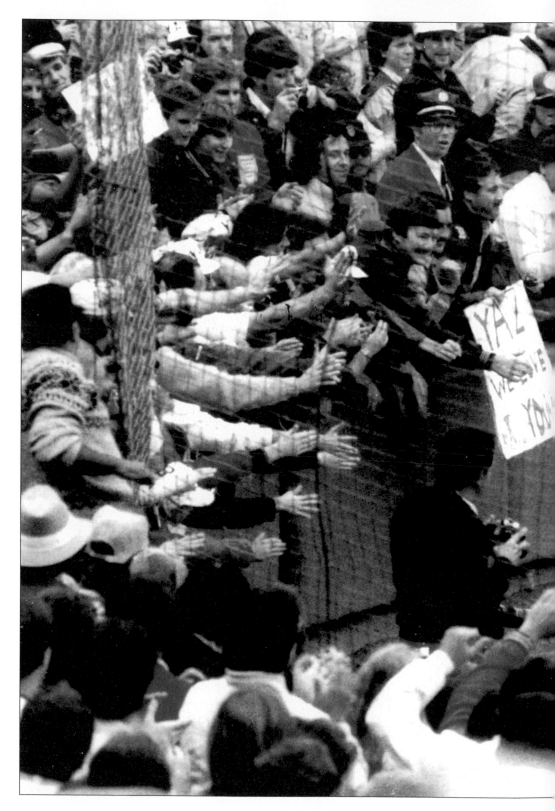

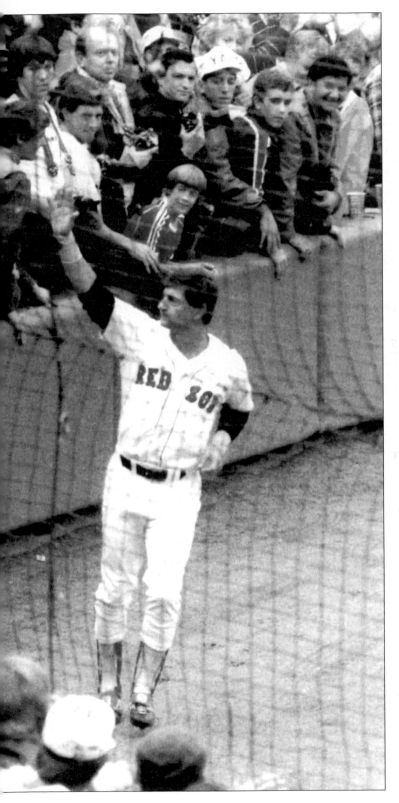

Just as the Rooters took to paying tribute to stars like Jimmy Collins at beginning of the 20th century, Sox fans in the 1980s were just as fervent in their admiration for Sox icon Carl Yastrzemski, as he bid them his Fenway farewell in this 1983 photograph. Yaz made his victory lap around the ballpark to the thunderous applause and adulation of the appreciative Boston fans. (Courtesy of the National Baseball Hall of Fame Library, Cooperstown, New York.)

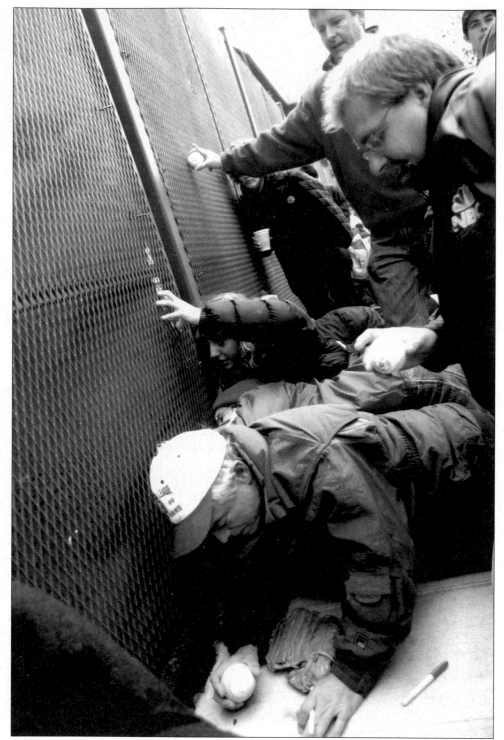

Sox fans young and old pass balls beneath a barrier on the street outside Fenway for player autographs. The craze was started a century before by original autograph hounds like Nuf-Ced and Charlie Lavis. (Courtesy of Brita Meng Outzen.)

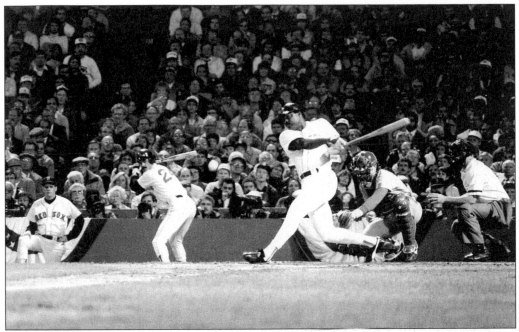

This image shows Lib Dooley (over the right shoulder of the batboy) watching the 1986 World Series at Fenway Park. (Courtesy of Tom Heitz, the National Baseball Hall of Fame Library, Cooperstown, New York.)

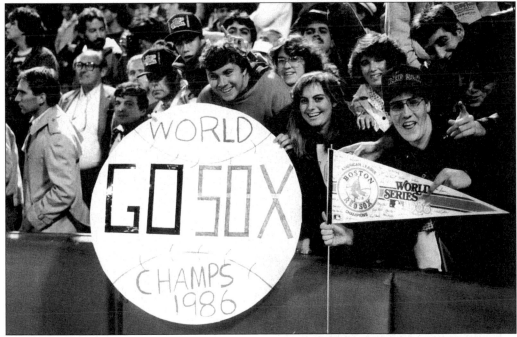

Sox fans anticipated the ultimate victory during game six of the 1986 World Series only to experience the sheer horror of a BoSox collapse, a la Bill Buckner, and the further manifestation of the Curse of the Bambino. (Courtesy of Tom Heitz, the National Baseball Hall of Fame Library, Cooperstown, New York.)

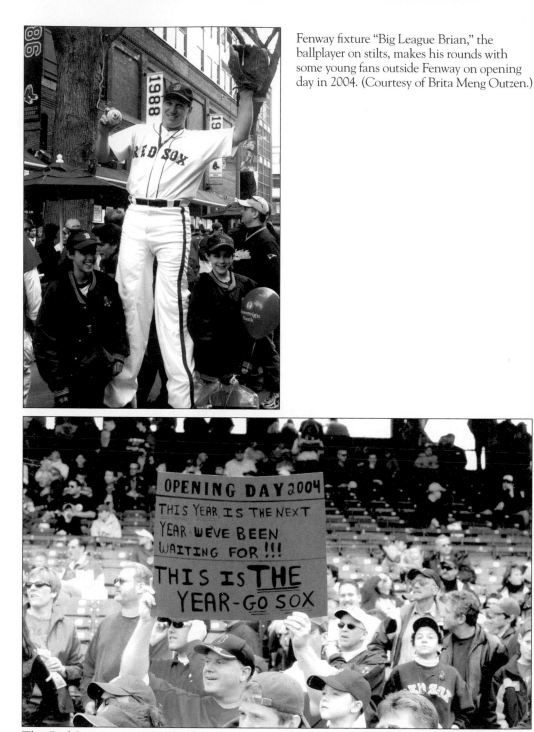

Fenway fixture "Big League Brian," the ballplayer on stilts, makes his rounds with some young fans outside Fenway on opening day in 2004. (Courtesy of Brita Meng Outzen.)

This Red Sox rooter made a bold opening day prediction in 2004. It is unlikely that he had some inside information on how Dr. Charles Steinberg and the Dropkick Murphys were going to revive "Tessie" later in the season. Before the 2004 campaign, Fenway's PA system had only kicked out old standards and fan favorites like Neil Diamond's "Sweet Caroline" and the Standell's "Dirty Water." (Courtesy of Brita Meng Outzen.)

Nine

THE RETURN OF "TESSIE"

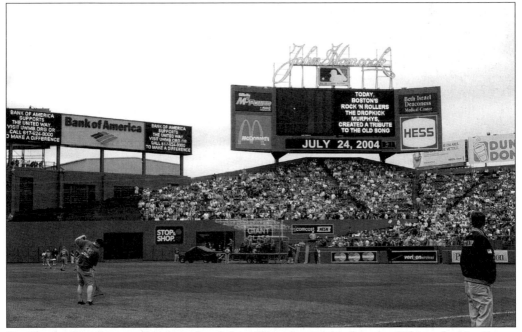

Dr. Charles Steinberg set the groundwork for a "Tessie" revival in January 2004, at the Hot Stove, Cool Music event, where *Herald* beat writer Jeff Horrigan suggested that he talk to Ken Casey and his band, the Dropkick Murphys. Casey and Horrigan rewrote the song, and studio sessions featured Johnny Damon and Bronson Arroyo on backup vocals. A CD was produced to benefit Red Sox charities. "Tessie" was played on a boom box for the Red Sox brass, who rolled their eyes and chuckled a bit. On July 24, 2004, the center field megaboard keyed fans, proclaiming, "Today Boston's Rock n' Rollers, the Dropkick Murphys, created a tribute to the old song." Just as Nuf-Ced customized the original song, the 2004 version adhered to the Royal Rooter tradition. While the 1903 fans changed the lyrics from "Tessie, I love you madly" to "Honus [Wagner], why do you hit so badly," the Murphys sang, "Tessie, Nuf-Ced McGreevy shouted, We're not here to mess around, Boston, you know we love you madly." (Courtesy of Brita Meng Outzen.)

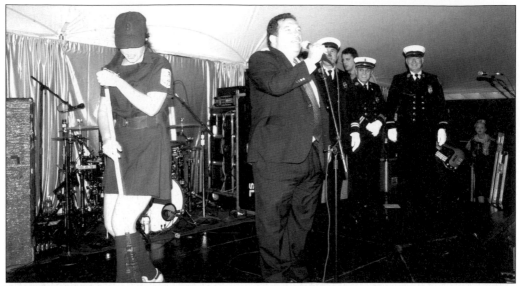

The champion of "Tessie," Dr. Charles Steinberg, introduces the band at a private party during the 2004 postseason. From the time the band made their first performance in front of 34,501 fans on July 24, an undeniable chain of events was set into motion that would ultimately prove the "Tessie" phenomenon was something to be reckoned with. (Courtesy of Grant Thayer, the Dropkick Murphys.)

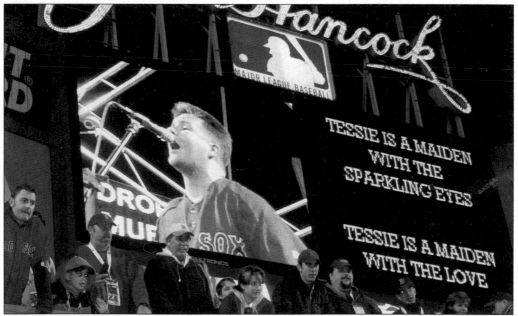

Ken Casey (seen here on the scoreboard with "Tessie" lyrics) is a lifelong Sox fan, counting Fred Lynn as an all-time favorite. As a kid, he ran around the field before games because his grandfather had ballpark connections and was friendly with Johnny Pesky. According to friend Ian MacFarland, he first founded the group with the thought that being in a band might help him get better tickets at Fenway. By the time he was approached to rework "Tessie," the band was already a successful entity in the music world and had to consider how "Tessie" might infringe upon the group's credibility amongst their core fans. (Courtesy of Brita Meng Outzen.)

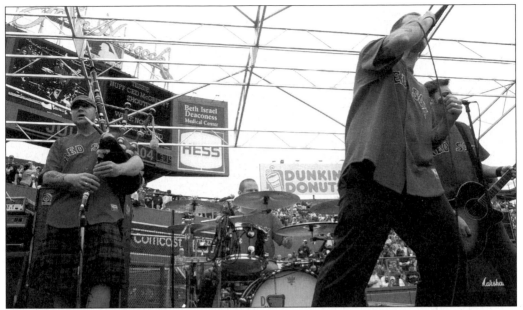

The Dropkicks have a knack for reworking traditional Irish songs and feature bagpipes on a number of their songs. Oddly enough, the original "Tessie" was written in B-flat, the only key possible for bagpipe play. Band member Scruffy Wallace blows on the pipes at the first Fenway show as the name Nuf-Ced McGreevy is reintroduced to Sox fans on the jumbo scoreboard. (Courtesy of Brita Meng Outzen.)

This right-field bleacher view shows the July 24 scuffle between Alex Rodriguez and Jason Varitek after the return of "Tessie." The slumping Sox needed a boost and what ensued was a classic matchup topped off by a dramatic game-winning home run by Bill Mueller in the bottom of the ninth. "Tessie" had finally returned to Fenway and her 21st-century record stood solid at 1-0. (Courtesy of Grant and Deb Thayer, the Dropkick Murphys.)

For their CD cover, video, and live performances, the band employed the services of a real life "Tessie" character played by Colleen Reilly. The band lines up with her here on the warning track, showing off their Sox jerseys complete with their last names, which could easily be mistaken for names included on the Royal Rooter roll calls during the first World Series in 1903. (Courtesy of Grant Thayer, the Dropkick Murphys.)

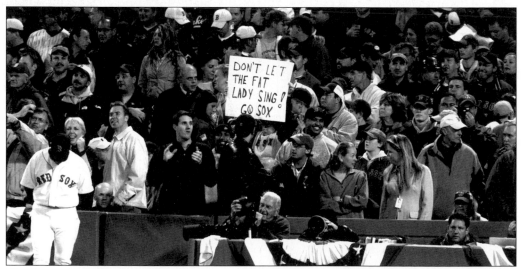

The first time the band performed at Fenway, Bill Mueller hit a game winner off of Mariano Rivera, and after their second performance during the playoffs versus Anaheim, David Ortiz hit a game winner of his own. "Tessie" was 2-0, and reporters began to note the coincidence. Anaheim was crushed and the Sox moved on to face the Yankees, who quickly took the air out of song's balloon, embarrassing the Sox by winning the first three games of the series. By game four at Fenway, the faith of the Boston fans was put to the ultimate test. (Courtesy of Brita Meng Outzen.)

Almost unbelievably, the Red Sox won the next three games to force a game seven. Although a baseball team had never overcome a 3-0 deficit, the Sox were on the verge. Thousands of fans traveled to the Bronx to witness either history or heartbreak. In New England, fans like the Erskine family of Portland, Maine, watched intently. John "Link" Erskine's family had made spring training trips for decades. His father once walked 100 miles from Portland to Fenway for the Jimmy Fund. He watched game seven with his wife, Chantelle, and daughter, Riley. If the Sox won, John promised Riley he would do something to their front lawn so that everyone could see how deep the family's loyalty ran. When Riley awoke the next morning to news of the victory, John and his friend Brian Foley began the process of painting the Sox logo on the front lawn. The final product, pictured above, caused quite a stir for local Sox fans and was featured nationally in the *Boston Globe* and the *New York Times*. (Courtesy of John Erskine.)

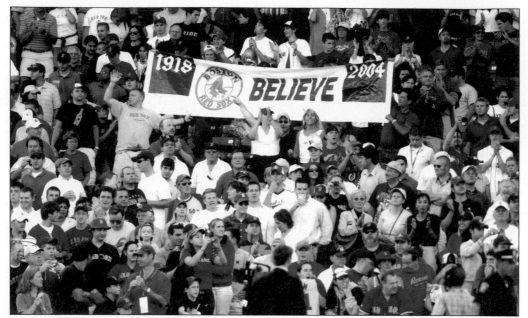

Stephen Boyd was as devoted a rooter as these Sox fans pictured above, but he was also the grandson of original Royal Rooter Jack Dooley. He battled lung cancer for four years through the 2004 season and followed the team with his brothers, who watched games at his residence where he was in hospice. As the season wound down and signs proclaiming "Believe" appeared most everywhere, it looked as if he would not live through the Sox postseason run. However, with his family at his side and with his brother Owen's belief that "the stars were aligned," he lived long enough to experience a World Series triumph. He passed away on the day of the Sox victory parade, having fulfilled the ultimate last wish of a Red Sox rooter. (Courtesy of Brita Meng Outzen.)

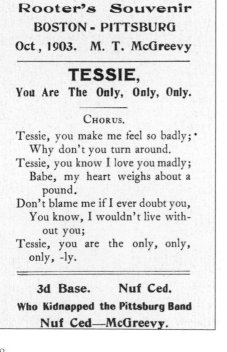

Stephen's brother Owen arranged for an original "Tessie" song card from 1903 and an original Royal Rooters pin to make the pilgrimage to the Bronx for games six and seven of the American League Championship Series, for good luck. These were the same good luck charms taken to New York 100 years earlier by his grandfather and Nuf-Ced to win the pennant of 1904.

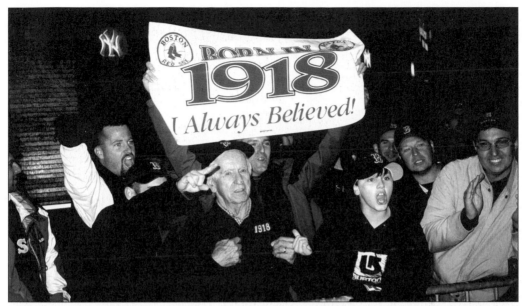

Just as the original Rooters did from 1897 through 1918, the new generation of Red Sox Nation overtook the enemy's home turf in their wild victory celebration after game seven outside Yankee Stadium. Among them was Oscar Dupre, from Chicopee, a rooter who was born 73 days after the Red Sox last won the title in 1918. Pictured under his sign, Dupre, who is legally blind and hard of hearing, stood outside Yankee Stadium until 2:00 a.m., cheering Boston's new heroes as they boarded the team bus. He was featured in a *Boston Globe* series headed "The Devoted." His stepson, Ted, described how Oscar fanatically carried his sign everywhere. (Courtesy of Bill Francis.)

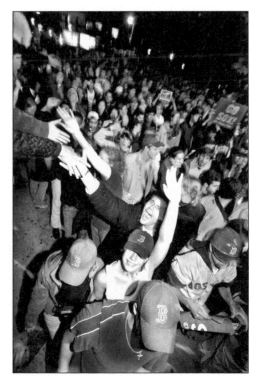

A new generation of Sox fans reveled in celebrations outside Fenway and around Kenmore Square after the Sox won the pennant. Tragically, one rooter, Victoria Snelgrove, was accidentally killed by a stray pepper-spray pellet as police enacted crowd control. (Courtesy of the *Boston Herald*.)

Dr. Charles Steinberg got Ken Casey into a luxury box at Yankee Stadium for game seven and later invited the Dropkick Murphys to perform at a pre–World Series party for the organization back in Boston. (Courtesy of Grant Thayer, the Dropkick Murphys.)

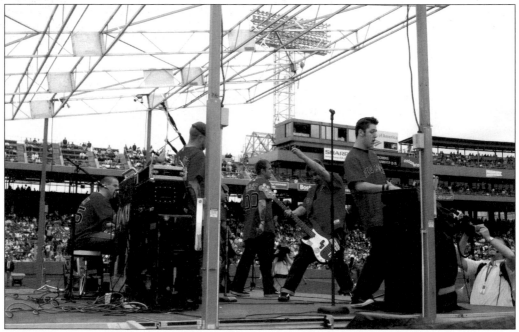

With their undefeated record at Fenway in 2004, the Dropkicks performed live again before the first game of the World Series. Once again, "Tessie" worked her magic as Mark Bellhorn delivered yet another game-winning home run off the "Pesky Pole" in the bottom of the eighth inning. (Courtesy of Brita Meng Outzen.)

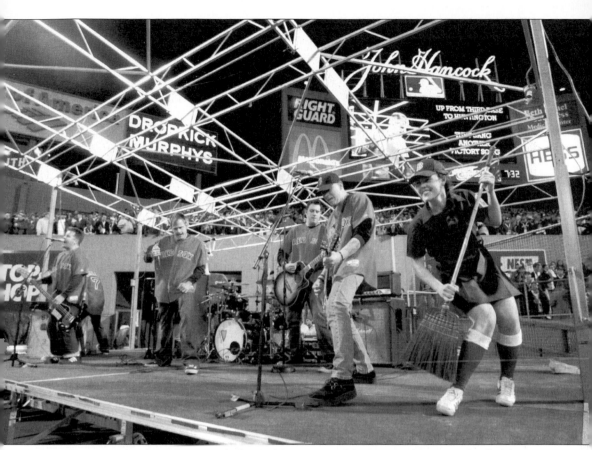

"Tessie" brings out her broom to signify the Red Sox sweep of the National League's Cardinals. In true Royal Rooter fashion, Ken Casey made the trip to St. Louis for games three and four of the World Series. Under the shadows of a lunar eclipse, the Sox got the last out and Dr. Steinberg, who was now referred to by Casey as "his favorite person in the world," got Casey on the field to partake in the postgame celebration. (Courtesy of Grant Thayer, the Dropkick Murphys.)

In contrast to the local flavor of the rooters from Roxbury in the 1890s, the rooters of 2004 brought a distinct international flavor to Red Sox Nation. The littlest of Sox fans was the diminutive 26-inch Nelson De La Rosa of the Dominican Republic. A well-known Latin dancer and actor, De La Rosa became Pedro Martinez's good luck charm during the postseason of 2004 and prompted manager Terry Francona to admit that, upon first seeing him in the clubhouse, he thought De La Rosa was a doll and not an actual living person. (Courtesy of the *Boston Herald*.)

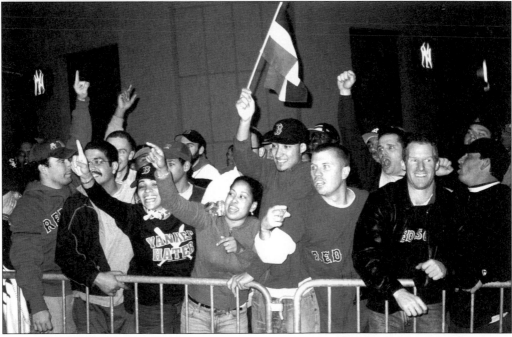

Paying homage to Manny Ramirez, David Ortiz, and Pedro Martinez, these Dominican Sox rooters stand outside Yankee Stadium after game seven, waving the Dominican flag. (Courtesy of Bill Francis.)

The Ferrelly brothers, Sox fans and movie producers, filmed their motion picture *Fever Pitch* during the postseason with the blessing of the Red Sox. Stars Jimmy Fallon and Drew Barrymore were filmed at Fenway and at St. Louis during the postgame celebration. (Courtesy of the *Boston Herald*.)

In a connection to the heyday of "Tessie," this bill of fare shows that Barrymore's granduncle, Lionel, was one of the artists who performed for the 1904 champions at the Boston Theatre. "Tessie" was the star of the show that night in 1904, and it appeared again, 100 years later, as a prominent Sox anthem in *Fever Pitch*, further elevating the Dropkick's version. After the movie premiere at Fenway, Sox owner Larry Lucchino turned to Dr. Charles Steinberg and apologized for his initial skepticism regarding "Tessie."

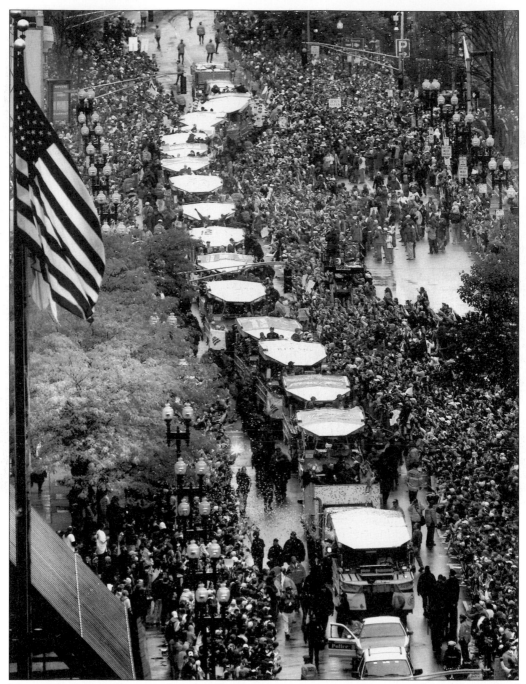

The celebration in Boston after the World Series was an awesome spectacle, as hundreds of thousands of fans flocked to the streets in inclement weather to honor the champions. In the tradition of the smaller parades orchestrated by Nuf-Ced and Honey-Fitz in their heyday, this celebration represented the ultimate realization by Hub fans that the title had finally returned, 86 years later. Dr. Charles Steinberg orchestrated the parade's route and details of the "rolling rally" with Mayor Thomas Menino and was sure to include a performance of "Tessie" by the Dropkicks in front of the statehouse. (Courtesy of the *Boston Herald*.)

With the World Series trophy home in New England, Dr. Steinberg and the Red Sox planned a victory tour of sorts for the new hardware to visit numerous communities and schools throughout the region. It was a huge hit with fans young and old to experience and view their "holy grail." In recognition of their team support, a special viewing atop Fenway's Green Monster was arranged for Ken Casey and the Dropkick Murphys, who got to spend some quality time with the trophy, which also made a visit to their recording studio. (Courtesy of Marianne Burke.)

Over a century after the successful release of "Tessie" on Broadway, the retooled song became a new favorite for many Sox fans who heard it on local radio, television, and at the ballpark. It was known to those close to him as the favorite song of Boston fan Dave Kroll of North Quincy, who tragically died after the World Series at the age of 24. In tribute to him, his friends and family members played the Dropkick's version at his wake and funeral service.

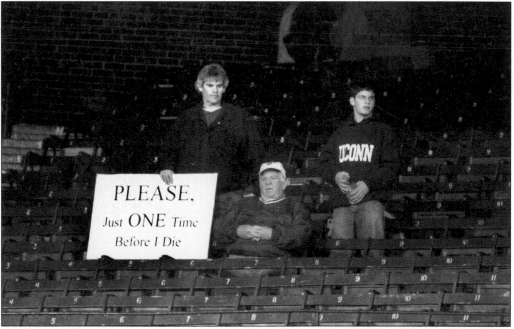

The sentiments of this Sox fan after game three of the American League Championship Series spoke volumes about the Boston rooters of the 21st century. By 2004, few living Red Sox fans could truly recall what it felt like to be a Royal Rooter in the triumphant teens of last century. (Courtesy of Brita Meng Outzen.)

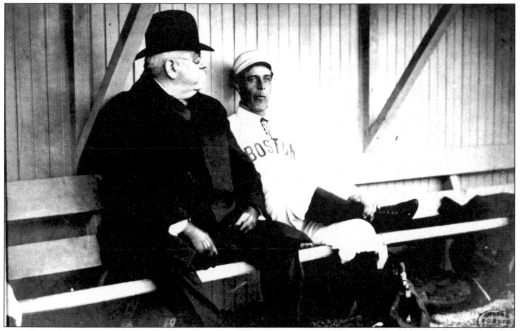

Celebrity fans are nothing new to Beantown and perhaps the "biggest" ever was heavyweight champ John L. Sullivan, pictured to the left chatting up Jimmy Collins in the dugout during 1904. Today's pack of modern-day rooter-celebrities are led by horror master Stephen King, along with actors Matt Damon, Dennis Leary, Ben Affleck, Lenny Clark, Ted Danson, and a host of others. (Courtesy of the *Boston Herald*.)

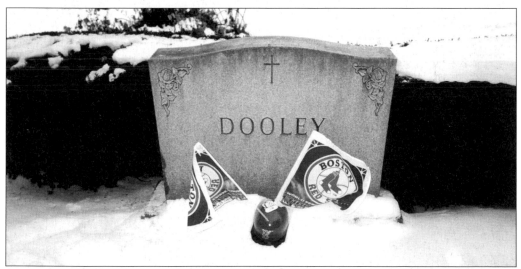

Unlike any other time in New England's history, family members made pilgrimages to local cemeteries to visit the graves of loved ones who had never experienced the joy of a Boston World Series triumph. At Brookline's Holyhood Cemetery, a fan paid tribute to the memory of the "Queen of Fenway Park," who herself was never lucky enough to experience a World Series victory. Her grandnephew David Leary stated, "Winning it all would not have changed her, baseball and the Red Sox meant more to her than just victories and losses. To Aunt Lib it was more about the friends she made at Fenway."

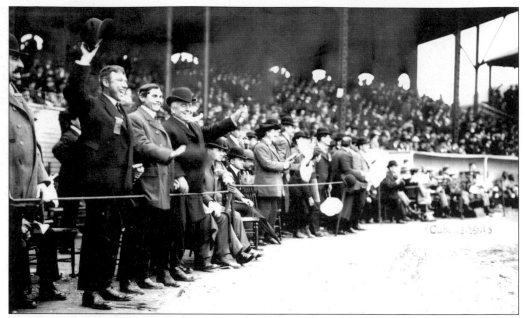

This classic image from the M. T. McGreevy Collection shows the original Rooters at the Huntington Avenue Grounds for baseball's first World Series. Their passion as avid fans is clearly visible in their gestures and facial expressions. Their generation established a regional fan base that has grown to immense proportions and has returned to glory in the modern era of the new millennium. (Courtesy of the BPL Print Department.)

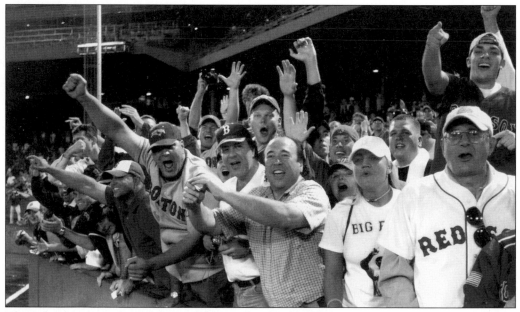

These fans were present at Fenway during the World Series of 2004, cheering wildly as they watched a live telecast of the game in St. Louis on the ballpark's mammoth screen. While the era of the Rooters was devoid of the marvels of our modern technology, the fans of yesteryear and today share the common bond of rooting for the home team, which is truly a timeless American tradition. (Courtesy of Brita Meng Outzen.)